P9-DGD-112

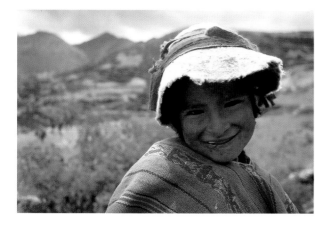
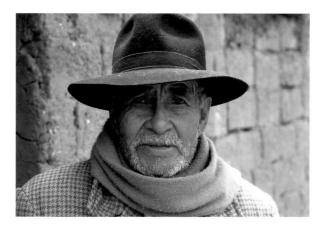
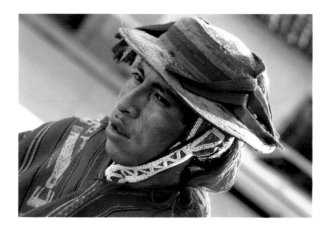
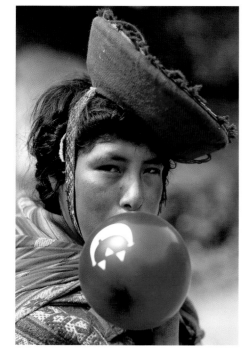

TRAVELLERSEYE

A TRAIL OF VISIONS
ROUTE 2

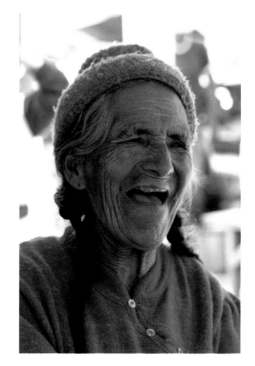
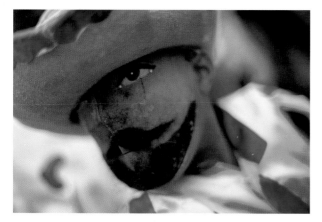
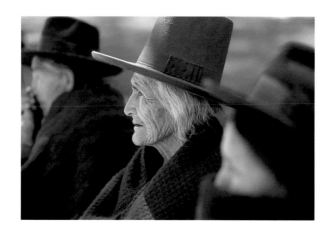
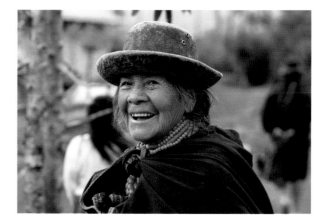

A Trail of Visions Route 2

1st Edition

Published by

Travellerseye Ltd

Head Office :

30 St Mary's St

Bridgnorth

Shrophire

WV16 4DW

United Kingdom

e-mail : travellerseye@compulink.co.uk

Published October 1997

ISBN 0 9530575 0X

This is a personal account of travelling through South America and although every effort has been made by both the author and publisher to provide correct and accurate information they accept no responsibility for any misleading or inaccurate information.

All rights reserved. No part of this publication may be reproduced, stored in a retrieval system or otherwise, except brief extracts for the purpose of review, without the prior written permission of the publisher and copyright owner.

Acknowledgments

Both Vicki and Dan were new into the publishing industry when we launched our first book - *A Trail Of Visions - Route 1* in November last year. Despite useful advice from other small independent publishers we couldn't have foreseen the on-going amount of work and effort needed not only in the sale and marketing of Route 1, but also the production of Route 2 and on-going development of Travellerseye. It has been necessary to have the support of both a number of companies and individuals, and would like to take this opportunity of thanking everyone.

We don't have the space to give thanks to all who deserve it, but we really do appreciate all support given. A big thank you to you all.

We don't feel able to finish off this acknowledgements page without mentioning a few in particular:

Campus Travel - for their overall support and enthusiasm for the series. **Joe's Basement** - for their help in developing the films for the photographs. **Kensington West Productions** - for their on-going help support and advice in all aspects of publishing. **Claire Gough** - for her efforts with editing and putting up with Dan's demands over the last few months. **Matt Barker** - for his help in the design and layout and general ability to help with computers. **Matt Jones** - for designing the books' jacket. **Nigel Brickell** - for being supportive and coping with the fits Vicki has had. **Micky & Bill Hiscocks** - for their support and advice, and general acceptance of their home and lives being turned upside down! And of course the rest of Dan's and all Vicki's families for their continual belief and support in Travellerseye.

We would also like to thank all those wonderful people that Vicki photographed and met along her travels who are the inspiration for the book.

contents

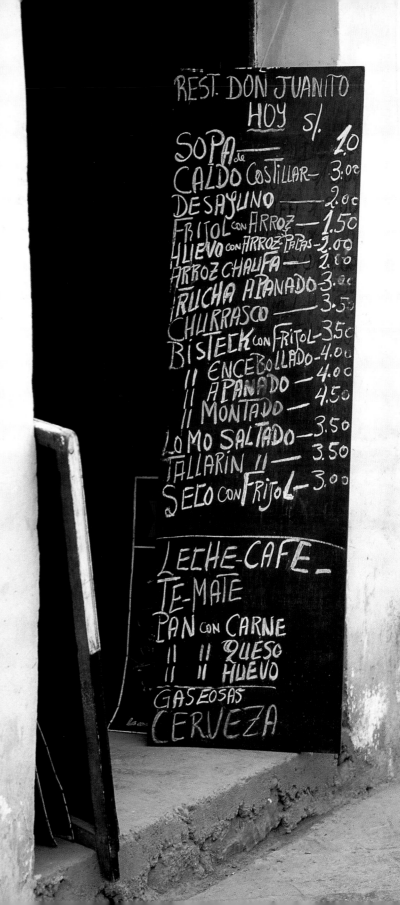

introduction

Learning Spanish before I left was a necessary requirement I chose to ignore. I now feel from my experience it is paramount to learn the language and I would urge everyone thinking of travelling to South America to commit themselves to it. It is a wonderful and exciting land with much to discover and explore, the vital link is the interaction with the locals. To truly understand, learn, taste, experience and feel the unique qualities it has to offer. It is necessary to be able to converse with the inhabitants. I had just over three months and felt I had little time to relax because there is so much to see and it is difficult to cram it all in, in the limited time. There was never a dull moment and each country has its own special qualities. The people are uniformly generous, kind and welcoming. There is a heavy influence from the USA, especially in the major cities, but the diverse culture and traditions are still strong.

Behind the historic ruins and places of interest it is possible to wander off the beaten track and become part of the country's whole essence - mixing with the people. You can stop to play chequers with some street kids, or help cook a meal in a home you have been invited to, or be taken to a local bar that you would never find in the guide books. Instead of being a tourist you begin to feel part of the scenery. If you look hard enough you can find an experience that isn't extraordinary or ordinary but one that is unique to you.

This book holds the key to those wishing to travel and for those wanting to understand the experience. It is an inspiration to finding your own path and personal fulfilment. Many people choose to travel with a guide book as I did for peace of mind, knowing how to get to places and finding your way around. Others choose to follow recommendations and word of mouth and see where fate leads them. There is no right or wrong but whichever path you choose you'll always get to the best places in the end. Travel is trial and error and you can only laugh at your mistakes and take them with you on your journey.

On a dark starry night look up and if you see the Southern Cross - you know you have come the right way.

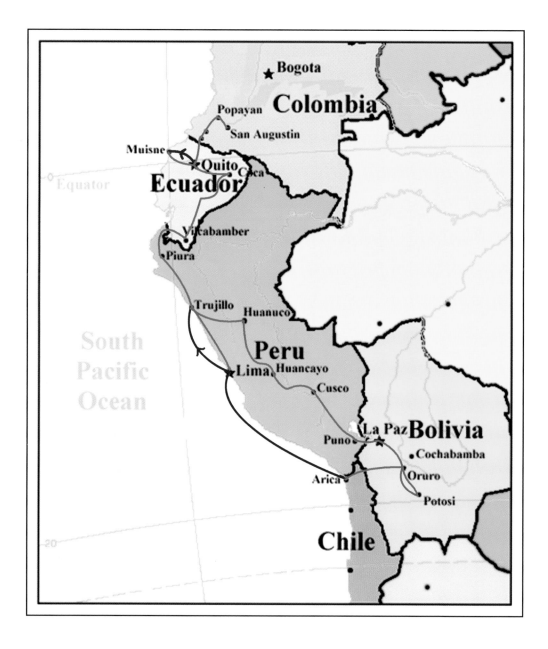

route

———	by land
———	by air

5

peru

I arrived in Madrid an hour late. A further three hour delay meant I missed my connecting flight from Caracus to Lima. With a twenty four hour wait until the next connecting flight, I felt sure we would be put up in a seedy hotel on the outskirts of town. The shuttle picked us up and drove us through the slum suburbs, passing numerous hotels on our way to the city centre. I could hardly believe it when we pulled up in front of the Hilton!

Having travelled before, I thought I knew the score. Previously I had made plans and broken them, and rescheduled flights countless times. This time I was happy to go with the flow and see where fate led me! I met up with a Spanish girl on the plane to Lima and decided to head up north with her to Trujillo, where she was working as a journalist. Due to the language barrier our conversation was limited and she, among other passengers, was concerned that I was travelling alone and couldn't speak the lingo. Prior to catching our bus, we decided to visit the Japanese Embassy which was under siege at the time. We blagged our way to the front line of the worlds press who seemed to be on a permanent coffee break. Compared to the hype and tension reported through the press world wide, the high drama siege seemed more like a camera convention to me!

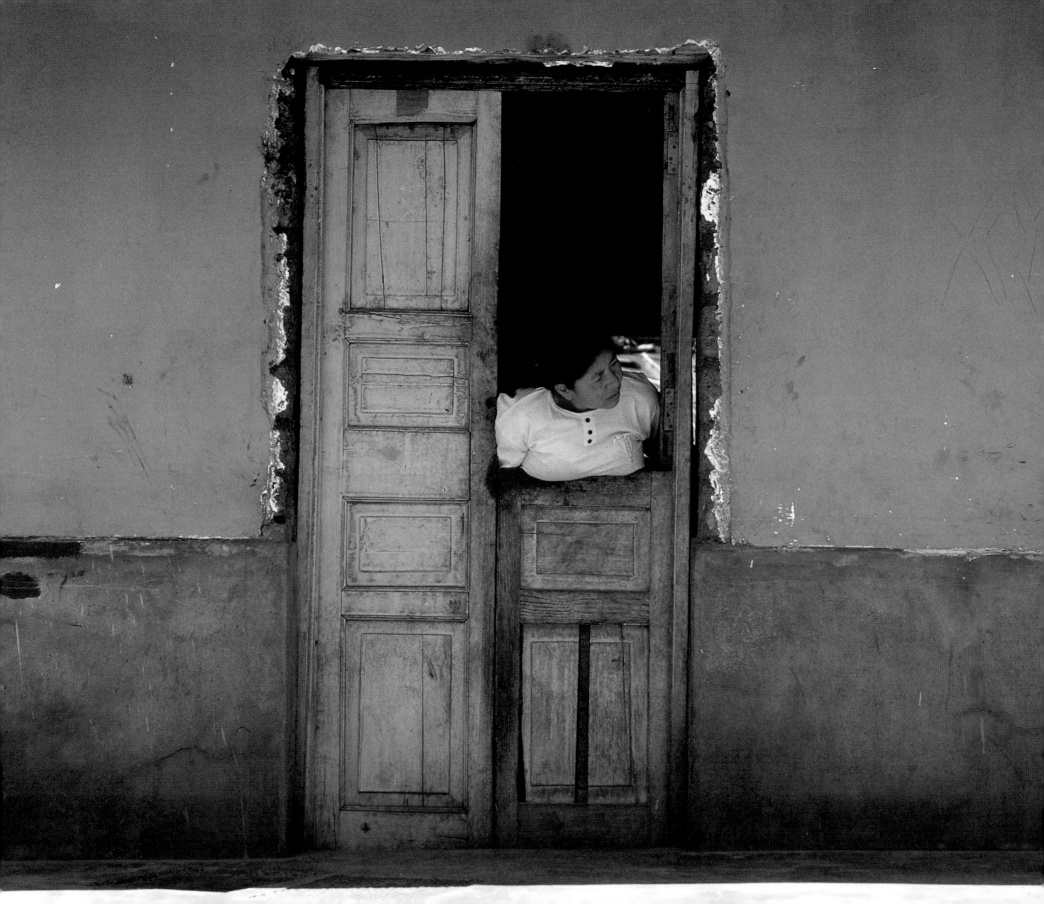

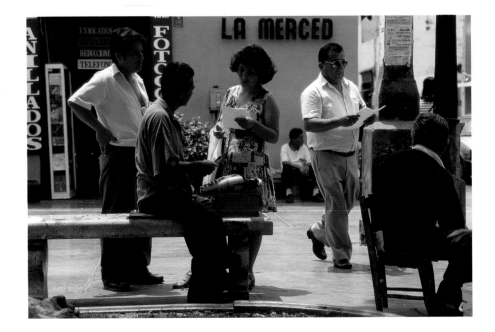

Trujillo, Peru's northern capital, is a pleasant enough city - full of traffic jams, shops, restaurants, and the chaotic bustle of modern city life. This is intermingled with scenes such as shoe shiners and men typing out documents on street corners. It was obvious from day one that English was rarely spoken by anyone and I spent the first few days in cafes, desperate to pick up a few necessary phrases and to try them out at any opportunity.

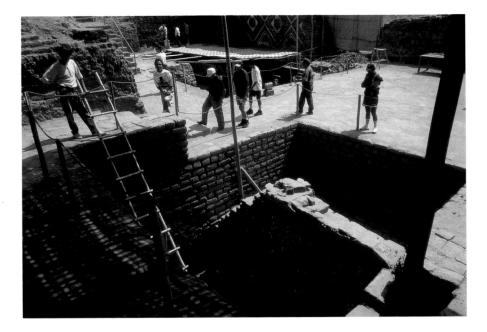

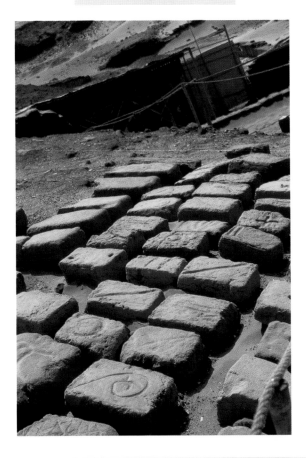

Hoping to absorb some culture I visited some ruins out of town. If I'd had a student or a teacher ID card it would have saved me a few bucks! The Temple of the Sun and Moon (Las Huacas del Sol de las Luna) was five kilometers south of Trujillo. These crumbling sandstone ruins were set in the desert and reportedly built around 500 AD in three days by two hundred thousand Indians. Having heard about their impressive history I was eager to see them but found them less than inspiring.

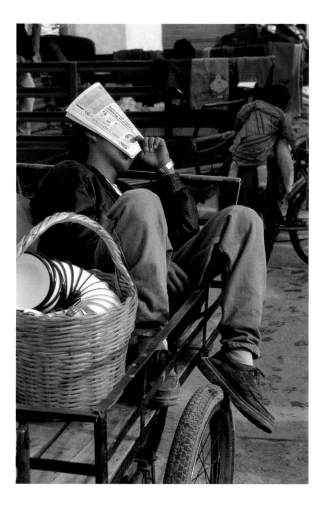

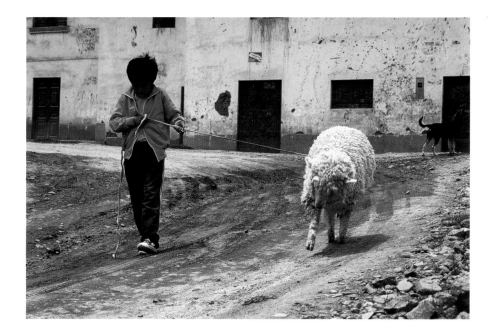

Leaving my friend, I travelled south west to Huaraz. I was anxious about what might lie ahead. I'd been told I look confident on the outside, but inside I'm a frightened little mouse yearning for a travel partner to take some of the pressure off. However, this laid back and peaceful mountain town was just waking when I arrived, and although I felt tired and could have curled up and gone to sleep I decided to take in the sights around the friendly quiet streets.

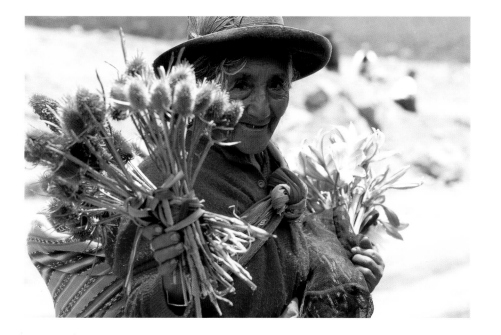

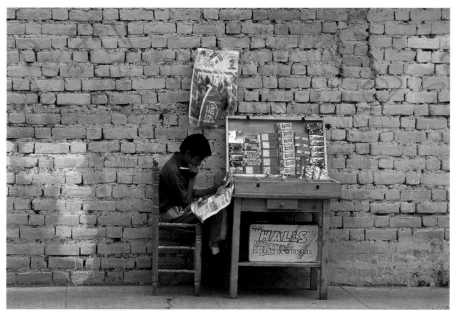

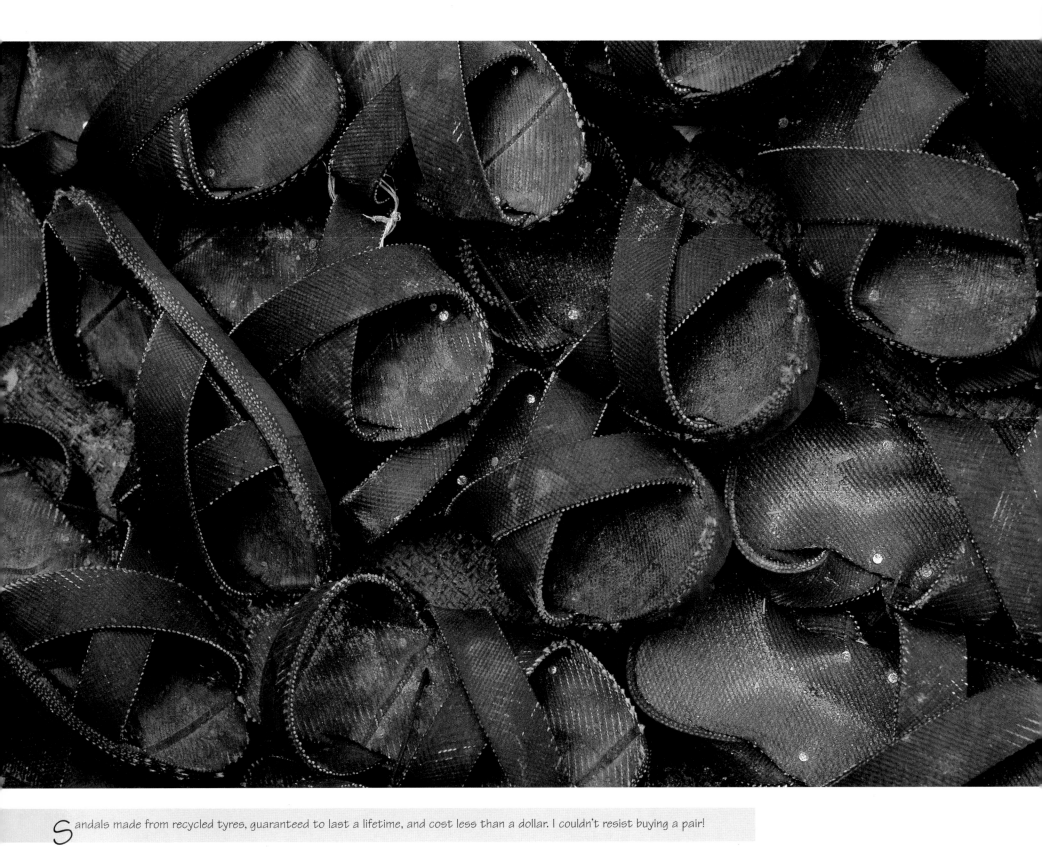

\mathcal{S} andals made from recycled tyres, guaranteed to last a lifetime, and cost less than a dollar. I couldn't resist buying a pair!

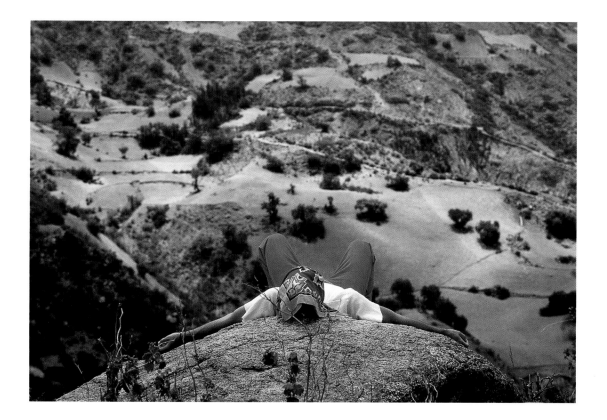

I feel like a refugee, alone in a foreign country where everything seems alien. I can't be understood and it's difficult to read the menus - even knowing which toilet is for women can be confusing. There is a lot of adjusting and to begin with there seem to be more hardships than fun. The valleys around Huaraz are the main centres for climbing, hiking and trekking in Peru. A day out in the mountains can be mind-blowing and up lifting - but exhausting for the unfit.

It is a great feeling of achievement when you successfully order a meal and actually get what you ordered, or purchase a ticket to the correct destination, or even learn your numbers sufficiently to enable you to bargain a room for the night! Sometimes life seems difficult 'on the road', until you are face to face with hardship, poverty and a real struggle to survive - and you realize that maybe you haven't got it so bad. You are paying for the experience. They are living it.

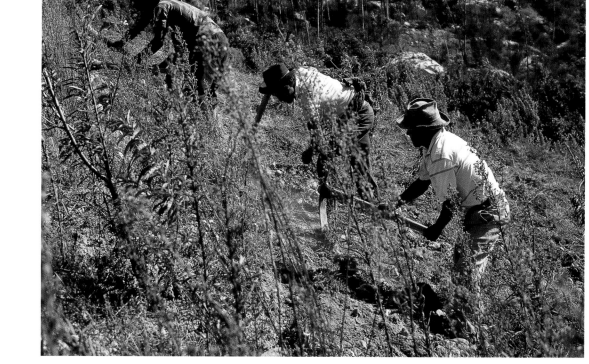

11

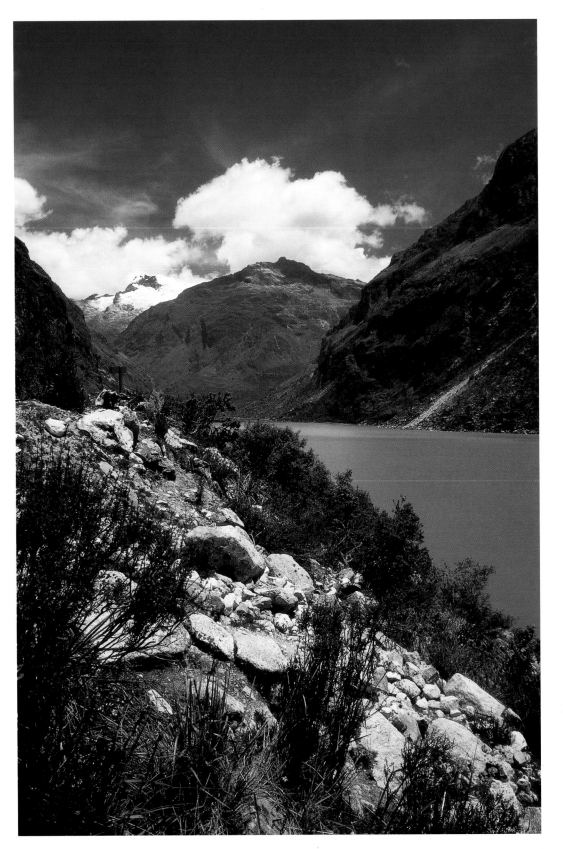

Like many travellers, I used Huaraz as a base and made a number of excursions out into the Cordillera Blanca Valley. Standing beneath Peru's Highest peak (Huascaran) and surrounded by the magical sapphire colours of the Langanuco lakes, it was not only beautiful but also peaceful and inspiring. All my fears were soon forgotten.

En route back to Huaraz it was impossible to miss the small town of Yungay, which was marked by an enormous statue of Christ, almost as big as the mountain that shadowed it. The old town has been developed into the region's major tourist attraction. It is the graveyard of the horrific 1970 earthquake. The remains of a school bus, submerged in mud, still stands as a reminder of the disaster in which twenty six thousand people were killed - almost the entire population of Yungay.

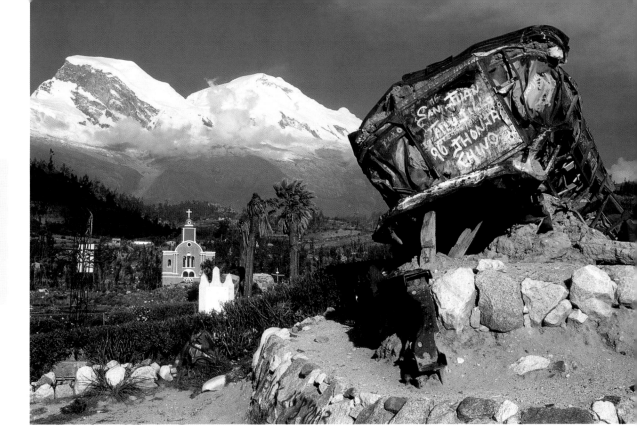

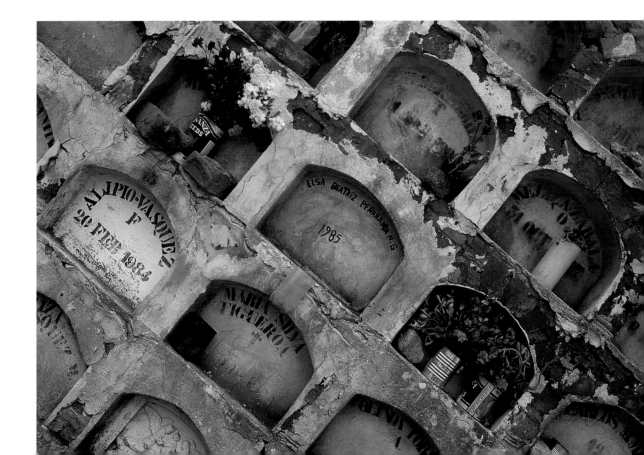

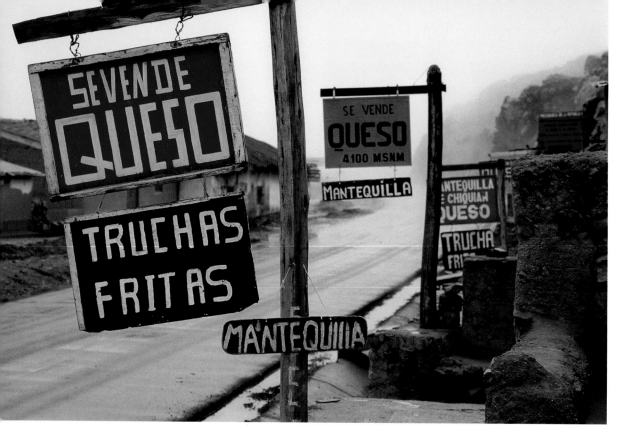

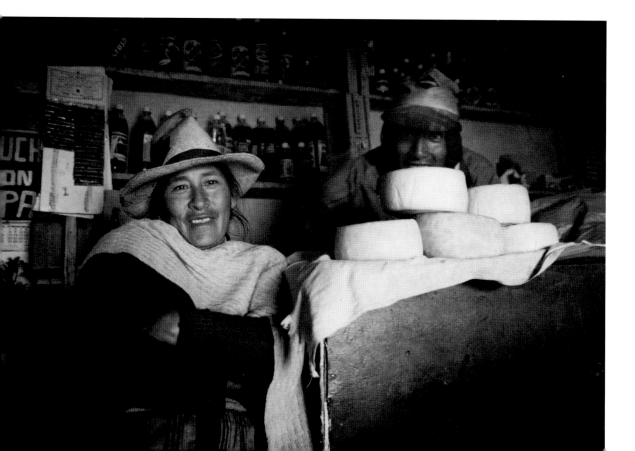

I was heading towards Cusco across the Andes. For the first part of my trip to Huanuco I was glad to hitch up with a couple of American guys from Denver (who incidentally knew a friend of mine from the Isle of Wight, it's such a small world!). We travelled together an untrodden path across the strange landscapes which finished in eerie towns swallowed up by clouds of fog, where they sold little else but queso (cheese) and mantequilla (butter).

Our journey took us through La Union and Catac. Modes of transport across fog covered highlands ranged from sitting up front in the cab of a lorry, to the roof or back of a pick-up truck normally used for taking sheep to market. Today the livestock was replaced with passengers. As cold and uncomfortable as we were, we broke the ice and killed some hours by singing for our fellow passengers. I'd heard enough horror stories to put me on a first flight back home and wouldn't have wished to have done this trip alone for fear of getting stuck somewhere. Many of the towns are isolated and have no facilities for travellers, but my two American companions made it possible to take this adventurous route which most foreigners avoid.

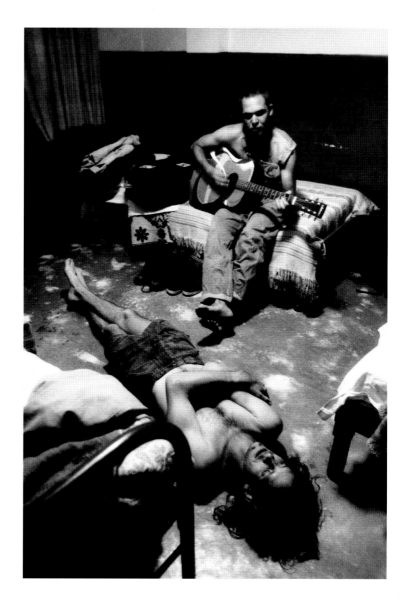

Twenty four hours later we arrived in Huanuco. We were shattered and battered! We went Peruvian with a bottle of cheap Chilean wine and a guitar - it was the perfect way to recover.

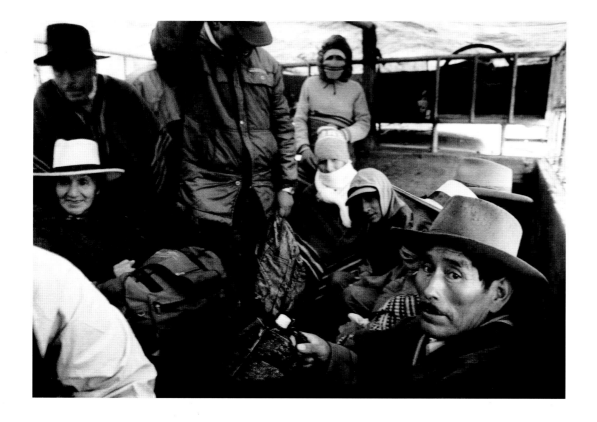

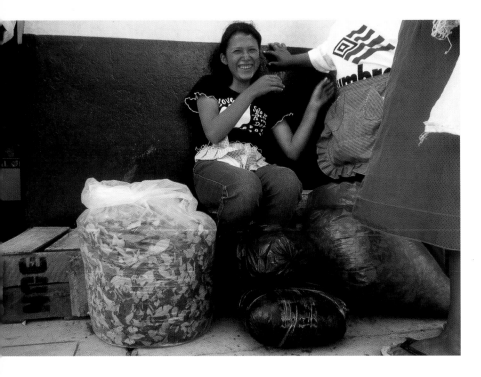

It was obvious that we were the first travellers to visit here for months as we were met with curiosity. In the markets Coca leaves were sold by the kilo and chewed between meals to relieve altitude sickness. We tried chewing a mass in search of a 'high' which amused everyone around us. It tasted disgusting, and turned our mouths green and then numb, but gave us a buzz to help us through an energetic afternoon stroll.

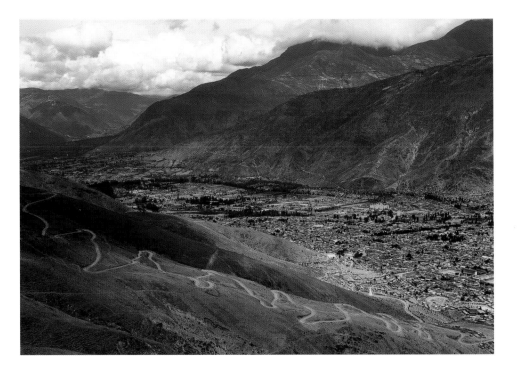

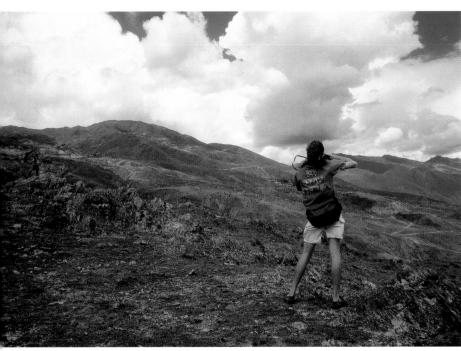

However you get there, however long it takes, when you get there it is worth it!

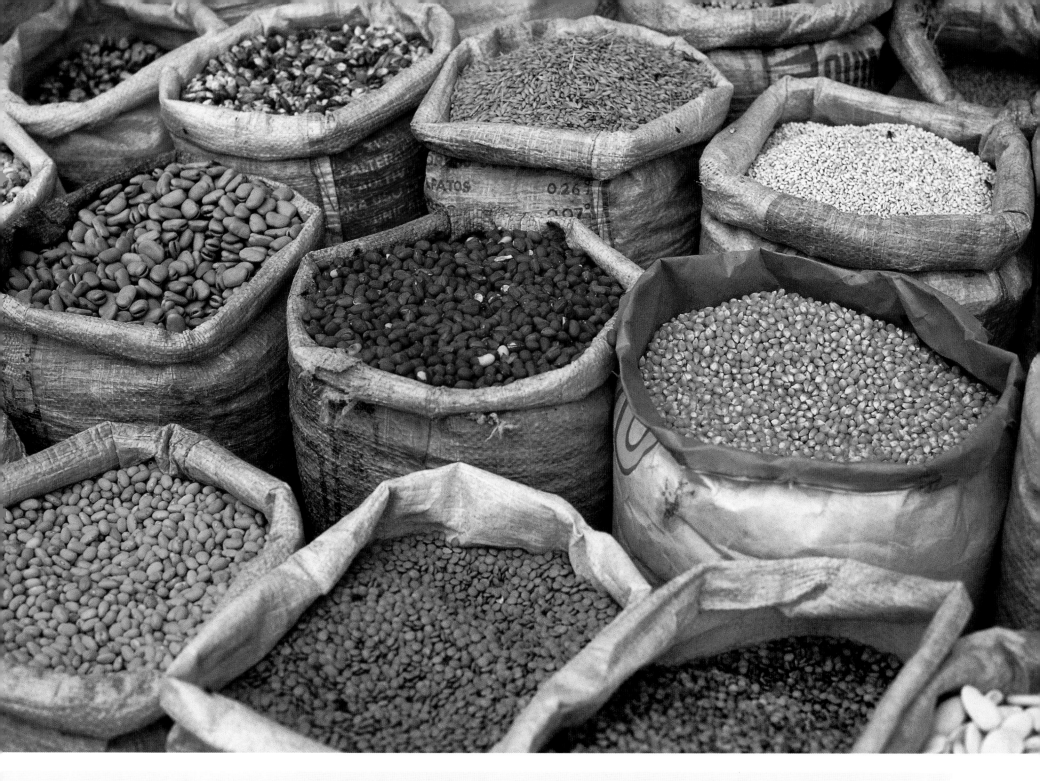

The walk had inspired me to carry on my journey alone. The guide books advise to avoid the route which I had chosen across the Andes in the direction of Cusco, as it would mean passing through areas which are seen as politically dangerous. In these 'chilled' surroundings I felt at ease and positive to continue, despite the warnings of bandits, and threats of kidnapping and robberies. Before leaving I visited the markets to pick up some food for the journey.

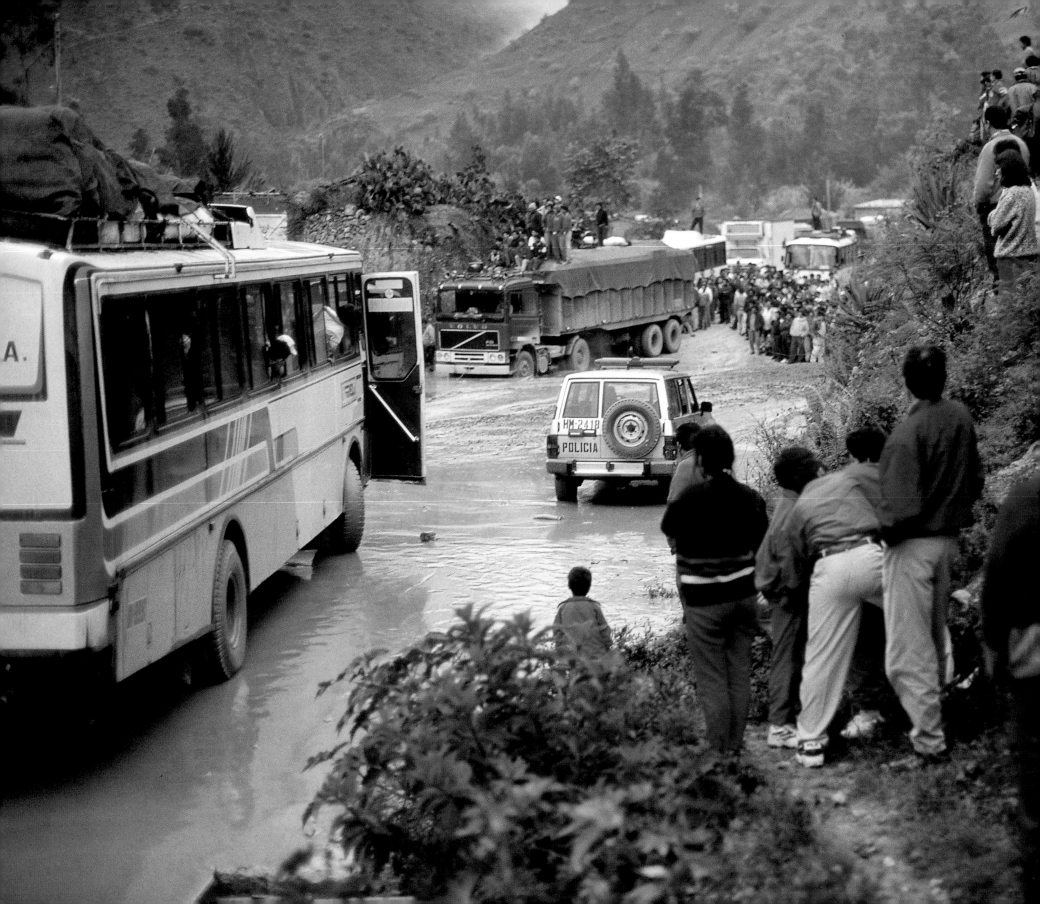

It should have been a simple eight hour bus trip to Huancayo, but heavy rains caused a landslide which doubled the journey time. Nevertheless watching the chaos was an adventure - it was Sunday when no-one works, so the road wouldn't be cleared for some time. It was a slow process, watching each of the hundred or so vehicles lined up along the highway, in turn getting stuck and then rescued from the quagmire.

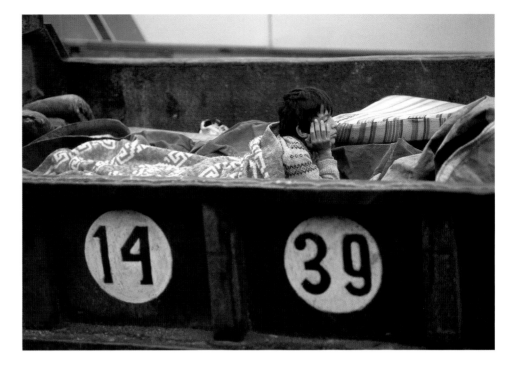

Stopping in the middle of nowhere for breakfast can be an eye-opener. In one cafe they served up guinea pigs which I had spied running around the kitchen a few minutes before. In another my companions ordered the set meal: the soup arrived with an unidentifiable object in it: jokingly I mentioned that I thought he'd got the hoof, and closer inspection revealed that it was - I stuck to dry bread and mangoes!

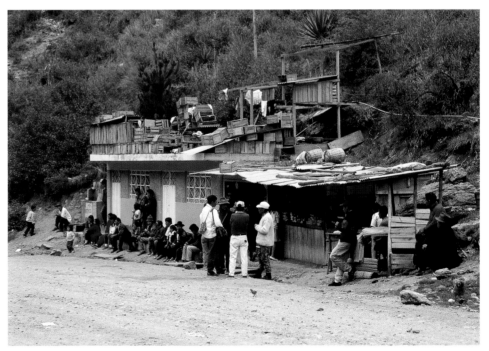

I found Huancayo claustrophobic and daunting so took up an offer from a guy I had met on the bus to visit some villages outside of the city. He'd told me he was a sheep herder but I soon realized I was being shafted when he came to pick me up while displaying a taxi sign on his dashboard. Despite this he stopped wherever I wanted and we got to many places off the public transport route and away from the hectic polluted haze of the city. I was also able to see where the traditional woven rugs and hand knitted jumpers of the area were being made which were then sold in the well known city markets.

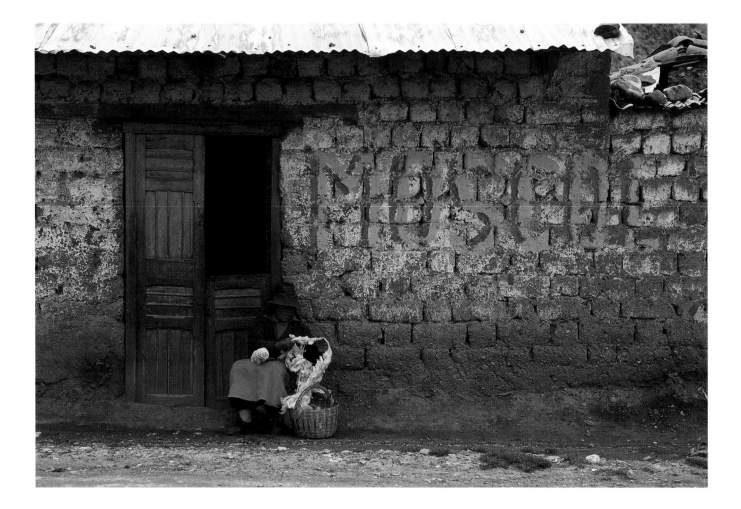

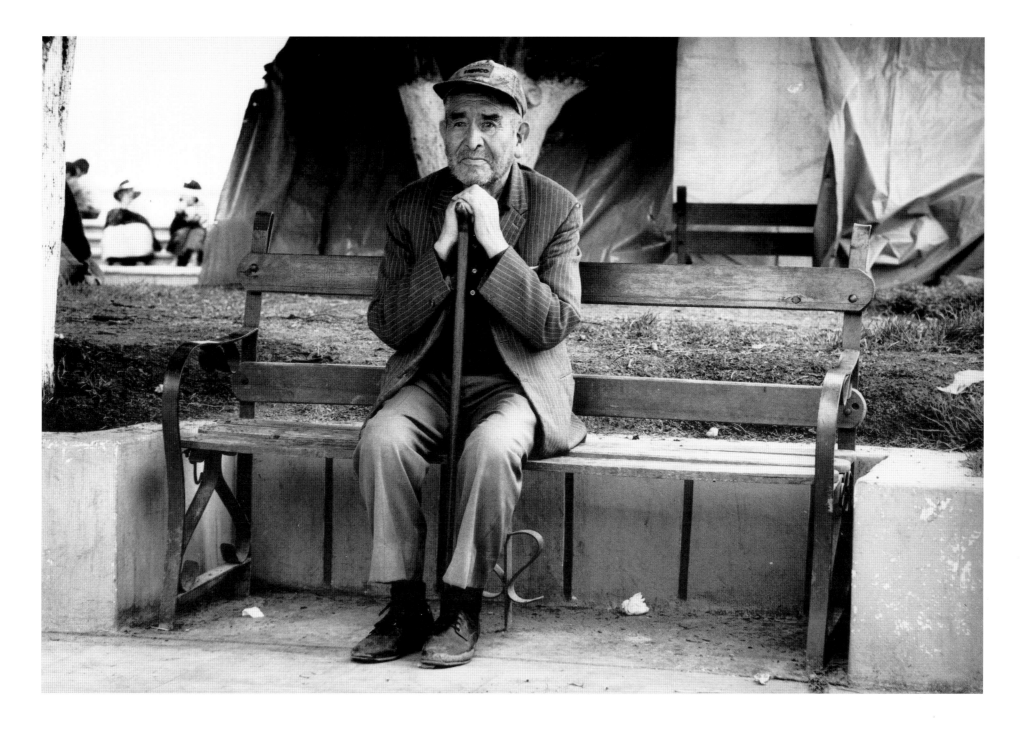

Visiting the village of Conception, we came across a small festival. Around the square children played table football, while others sat around or joined in the colourful procession.

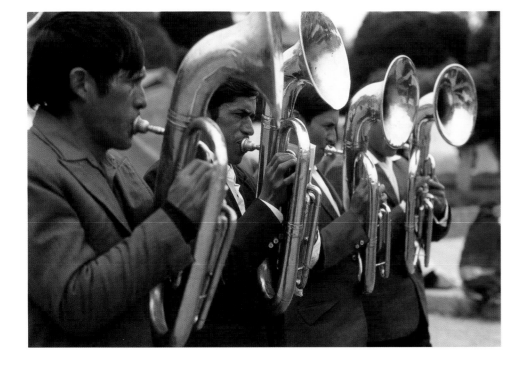

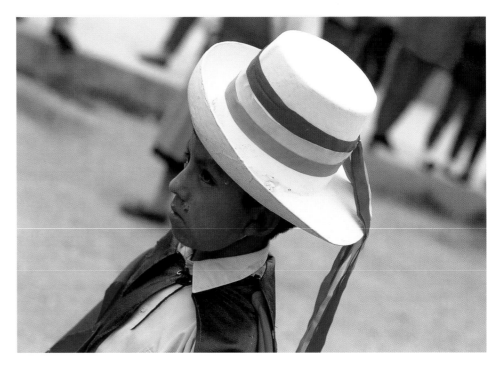

Villagers of all ages joined in and marched in step behind the band!

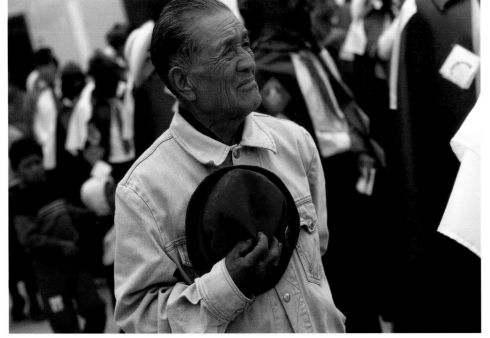

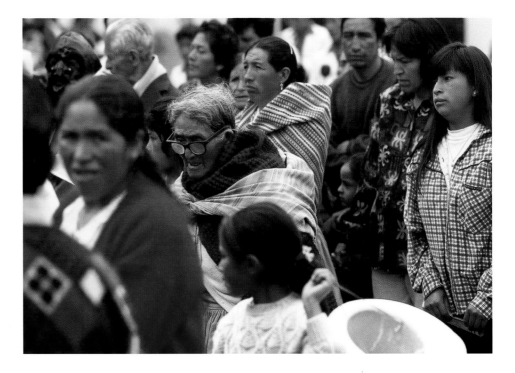

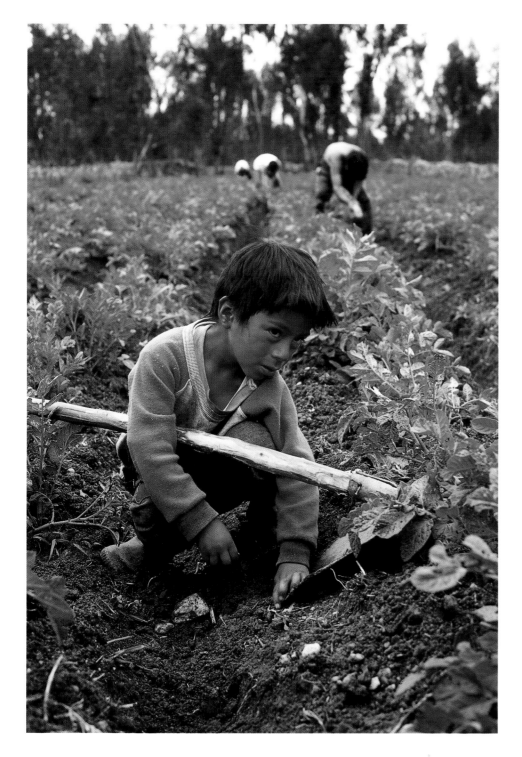

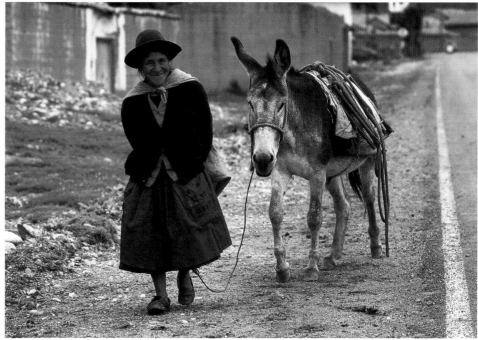

Down the road from Conception life was tranquil and the locals got on with their daily routines of working the land and exercising their animals. It is clear I am in a country where age is irrelevant if there's work to be done.

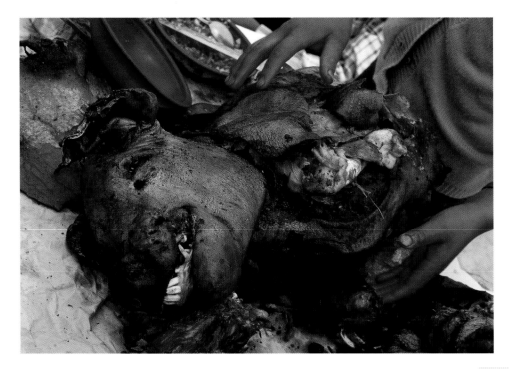

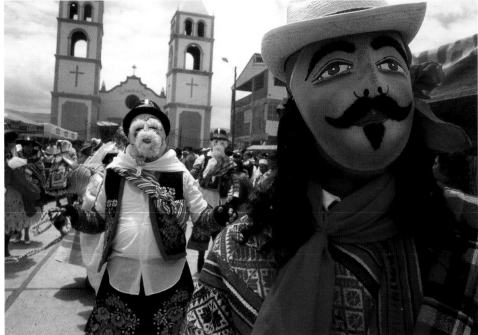

On the main highway back to Huancayo another carnival was in full swing. Carnivores would have been in heaven here with barbecued pigs and other burnt offerings on display for all to sample.

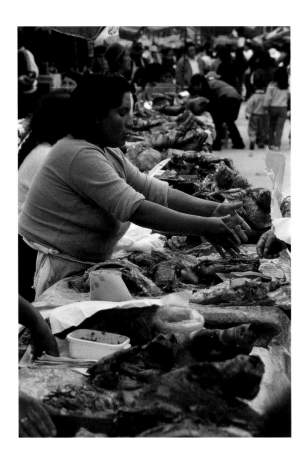

It was a marvellous experience to be the only tourist witnessing such a carnival. It wasn't at all commercial and was obviously for the community rather than for the tourists. It was only by chance I had found it and I felt privileged to be there. When inquiring about the purpose and history behind the dances, the only explanation I got was that 'it was traditional and originated in Spain'. It didn't explain a whole lot but no-one seemed to know or care. Enjoying the atmosphere was more important than the significance of the event.

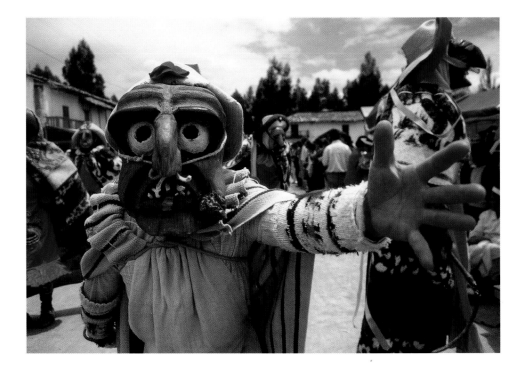

Back in Huancayo, shops and signs offering an assortment of merchandise and services caught my attention. I checked into a dodgy hotel - but with a name like Hostel Pussy what should I have expected. I left first thing the following morning on a bus to Ayachuco. Part of travelling is the unexplainable passion and desire to exist and achieve. The mission is to find your way around and to get a bed for the night that is within your budget, no matter what the surroundings. You have an idea of where you are going but everything is new and each day is a test. You learn from and laugh at your past mistakes, and take them with you on your journey.

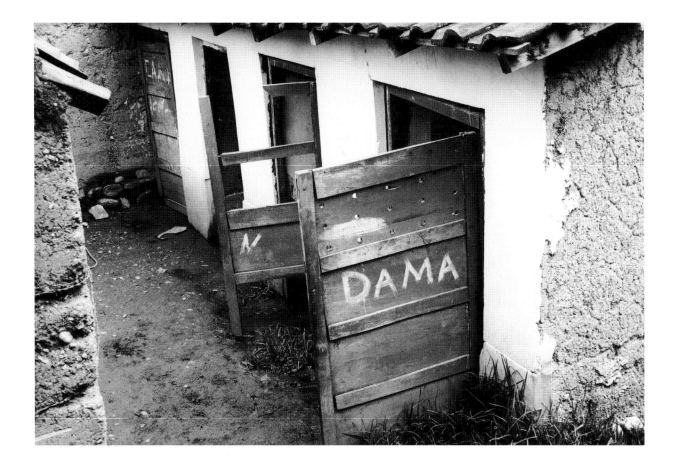

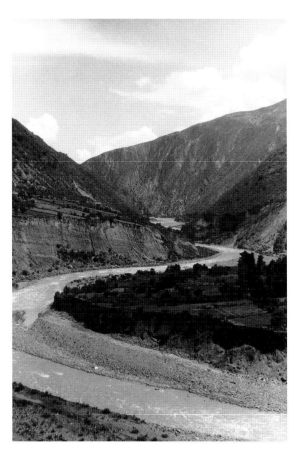

The Shining Path is an organization renowned for terrorist activity in this region. The fact that people disappear and the possibility of being taken hostage or robbed was the last thing on my mind, particularly when having to cope with the less than inviting conveniences, waiting an hour or two for a tyre change, or clinging on to my seat in fear of collisions. We climbed and descended each valley like a roller coaster, the scenery changing from a patchwork quilt of many colours to a barren landscape where locals farm cacti for its fruit which they sell in the nearby markets.

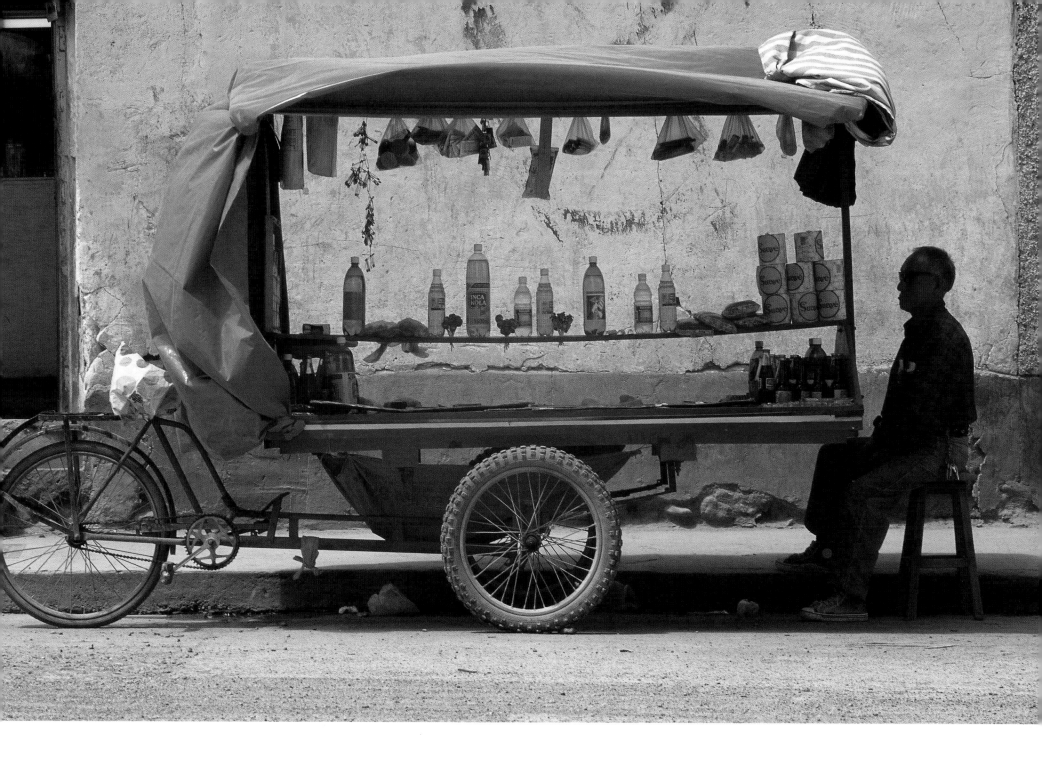

Despite its violent past (the presence of the military being a constant reminder) Ayacucho was the most tranquil and friendly town I had visited to date. The political situation is still said to be volatile but the route is open to travellers. I felt totally safe walking around the streets which are packed with colonial architecture and laid back scenes.

The main square is the focal point in each town, village and city in Peru. Known as the Plaza de Armes, they are always well kept, and decorated with flower beds and sculptures, whatever the surroundings. I spent a few hours making friends with street kids. Vending boys tried to sell me sweets and cigarettes, and their patience and ability to guess what I was trying to say helped me practice my Spanish.

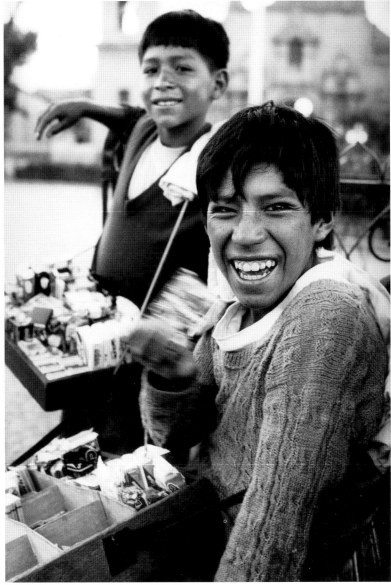

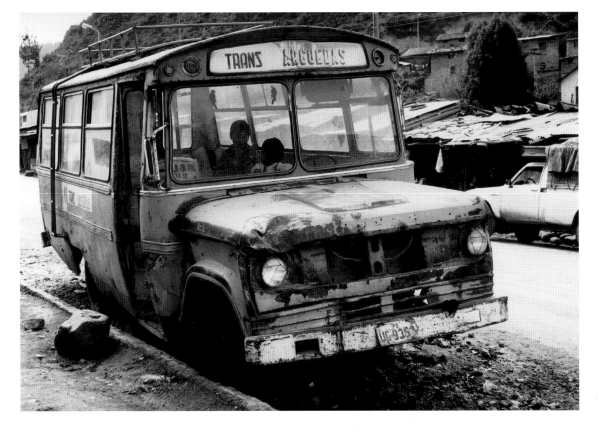

Booking a bus to Cusco initially seemed a nightmare as the bus company I went to said there were no buses except via Lima, which would not only be costly but take ten thousand years! The tourist office pointed me in the right direction (a dodgy back street) and eventually I found the right place. On the way to Andahuaylas the roads became more treacherous. I sporadically fell asleep and every time I opened my eyes the views had changed. It amazes me when locals jump off the bus in a barren deserted landscape - where do they live? The further you travel into the mountains the more basic the toilets and transport become. On one memorable journey I realized that the bus had no brakes. Every time the bus came close to a head-on collision the driver thrust the gears into first, bringing the vehicle to a catapulting halt!

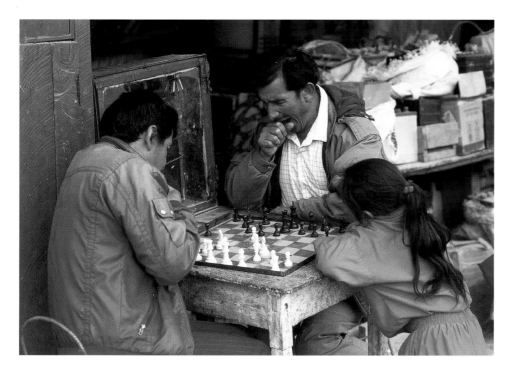

I was so struck with the peace and calm of the small town of Andahuaylas and the surrounding lush valley, that I decided to change my plans to catch the connecting bus to Cusco. I walked around town and chatted with the locals. I was slowly picking up the language, gaining in confidence and felt I knew the essentials even if I didn't understand what was being said to me in detail.

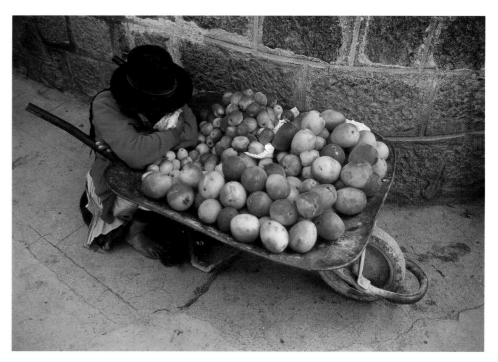

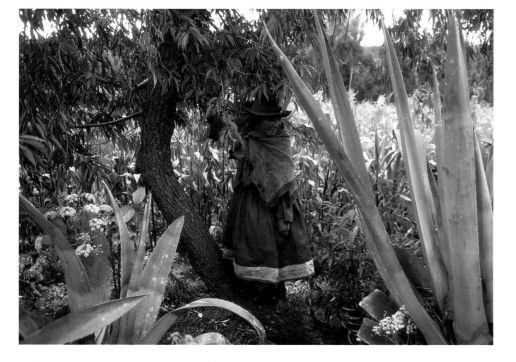

I went for a walk out of town and was suddenly hit by an awareness of solitude. Watching the local people, I reflected on my last three weeks and chosen path across the Andes (I had only met two other travellers). It felt good that my instinct had led me this way despite warnings about leaving the 'gringo trail' and it was satisfying to know that I was truly off the beaten track. I watched a local woman collecting berries from a tree - a young girl was exercising her cow. This natural silence was sometimes broken by the 'collective vans' (which carry people and produce). They beeped their horns more often than was necessary and sounded more like space invaders. The continuous wash of the river nearby helped to mellow their mechanical chorus.

Cusco is famous for being the capital of the Inca Empire. In 1200 AD the population of the Inca tribe was no more than forty thousand, but by the early 16th century they had become one of the largest empires in the world with over a million subjects, and stretching geographically from southern Columbia to northern Chile. Like most foreigners, I had come here particularly to see Machu Picchu, the lost city of the Incas. Cusco was a stark contrast to the other towns I had passed through when travelling over the Andes. It is the centre of the travel network and is surrounded by some of the most important Inca sights in South America. The old part of the town is a warren of tiny streets with whitewashed houses with terra-cotta roofs, while the middle of the town has many interesting colonial buildings. It is a place full of energy, colour and atmosphere. The many restaurants and bars overflowed with tourists from every continent. Souvenirs, jumpers, socks, gloves, hats and a variety of other woollen garments crowded the pavements. It is a wonderful place to explore, every day is market day and it is difficult to resist buying another accessory.

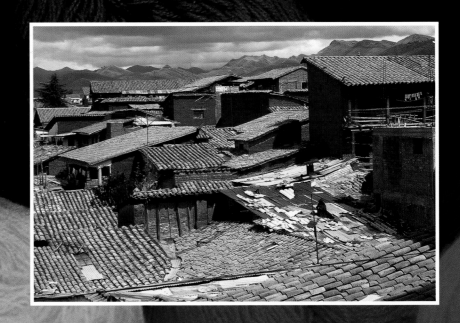

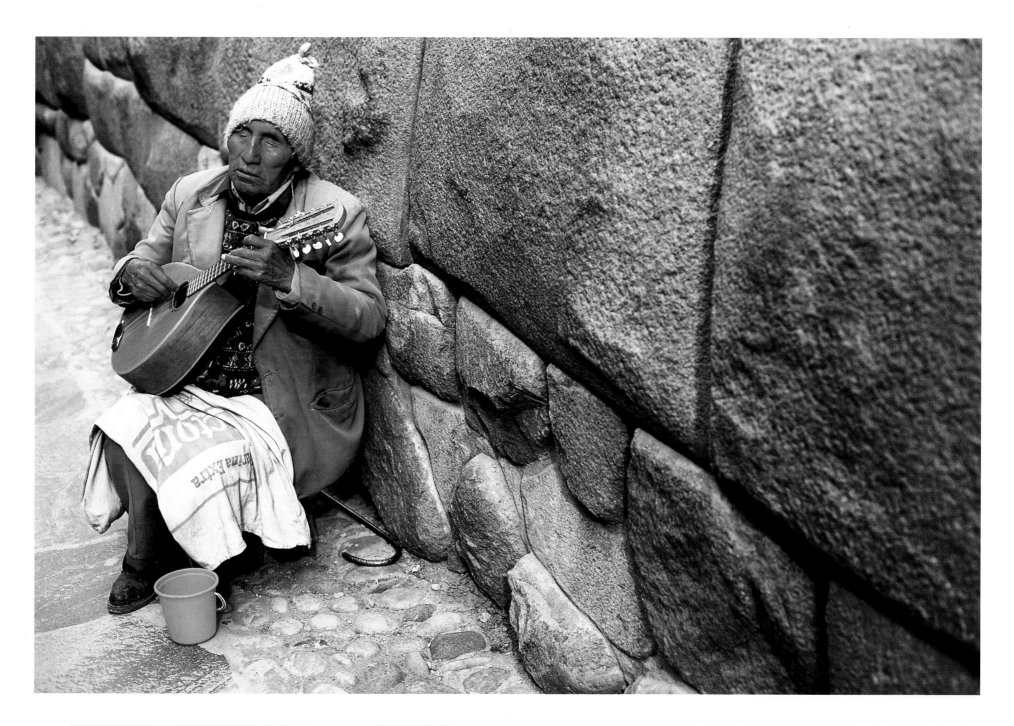

Music filled the town day and night. The mellow street musicians during the day contrasted with the evenings when most tastes were accommodated - from traditional Andean, to Salsa, Techno, Rock, Pop or Rave. It was comforting being surrounded by so many other travellers. I took up a recommendation from an English couple and booked a tour with them to walk the Inca Trail. Having so much choice can be confusing, but it is always worth looking around at various companies to see what they have on offer.

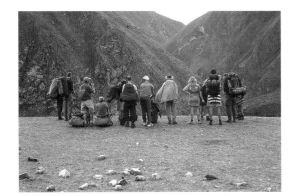

1

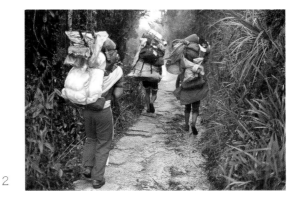

2

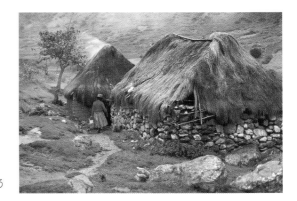

3

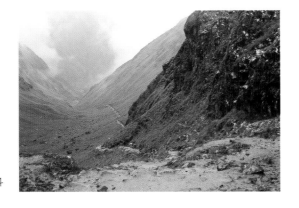

4

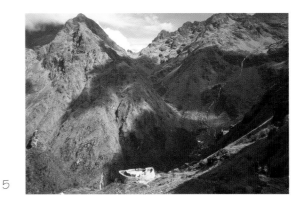

5

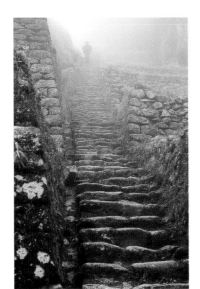

6

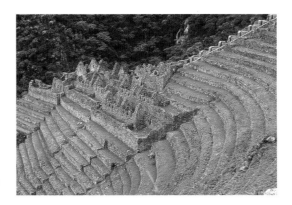

7

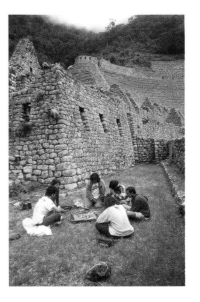

8

1 We started the trail at kilometre eighty two, and had forty nine to cover in four days. Five English, four Australians, two Swiss, one Danish, one German and one American took to the trail. After the first two hours of walking with our backpacks, most of us had sworn to hire a porter the next day, no matter what the cost!

2 The porters, having loaded up the tents, food and cooking utensils onto their backs, left us and went on to prepare the next camp and get a meal ready for us when we arrived some time later. Every year they have an annual race, and the record stands at three hours and forty minutes - for the same route that took us four days!

3 The scenery was beautiful, but it was hard to take it all in as I was mesmerized by a pair of 'Nike' trainers in front of me. As the path was so uneven it was difficult to look up. I literally saw the Inca Trail from ground level. The guide did his best to explain the healing properties of certain plants, as well as provide us with the history of the trail we were trekking. Our first camp was the only inhabited farming community on the trail. The locals carried on with their business, feeding their farmyard animals and themselves, while a load of tourists wandered about. I felt very conscious of being a tourist here, aware of invading their space, dressed in clothes made by them but not for them.

4 Warned that the second day was the hardest climb, we had not expected to reach the top of the pass at below zero temperatures in a snow blizzard and dressed only in shorts. Why had the Incas chosen such a harsh trail? What was at the end of it?

5 Our second camp was a bog of mud and not fit for humans. Despite this, the view was breathtaking and as one fellow companion pointed out "There's always a positive to a negative". It seemed to me that a reason for walking the Inca Trail was to experience similar hardships to those felt by the Incas hundreds of years ago. At times it felt hard, but our porters made it relatively easy. We didn't have to lift a finger. Although meal times were uninspiring, we could hardly complain about the porters' lack of culinary skills when they were being paid the equivalent of fifteen pounds sterling for four days hard graft!

6 The weather was the down side to the trek, and our early morning starts meant that the fog had hardly lifted and our views were obscured. The impressive ruin of Payupatamarca, known as 'The Town Above the Clouds', was unfortunately totally submerged in fog.

7 The most impressive ruins en route to Machu Picchu were those of Winay Wayna, with steep terraces overlooking the valley.

8 Other tour companies offered 'alternative' tours influenced by Shamanism, eco-friendliness or concentrating more on the spiritual side of the Incas' history. Whilst at Winay Wayna, we came across a group meditating and offering Coca leaves to the Gods.

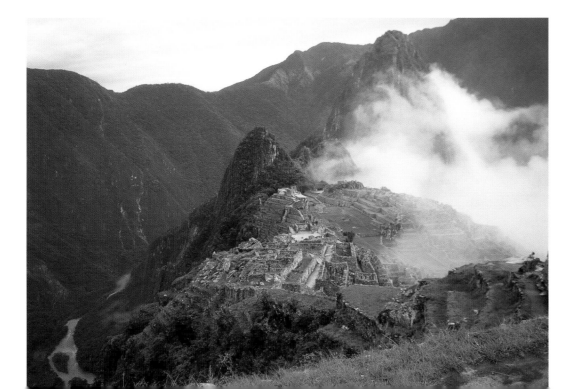

Our first views of Machu Picchu were seen through the thick clouds. Within sight but out of sight. We sat recovering from our final trek when suddenly the opaque whiteness dispersed - the scene made the whole trek worthwhile.

Wanting to explore the ruins for myself, I left my group who were being frog-marched around and having their minds bombarded with information which was impossible to understand due to the bad translation. The ruins were a maze from above and within. Exploring them, I felt transported back in time, lost but not afraid. Each corridor led into another, a flight of stairs or a new room. I could almost visualize the Incas' life going on around me revealing the purpose of each new area or room without any explanation from the guide. But the magic that Machu Picchu holds is not only in the ruins but in its surroundings. The whole experience defies description.

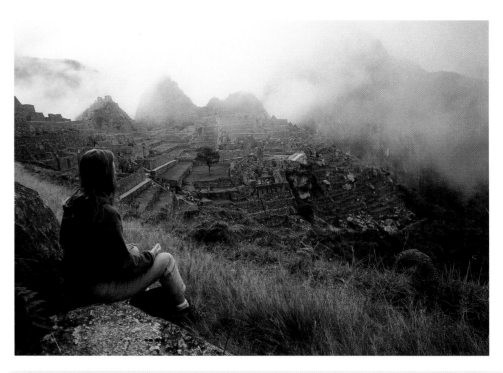

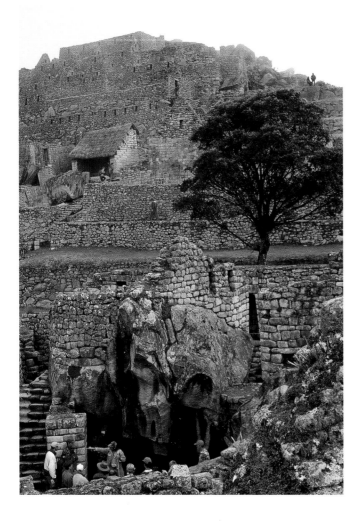

Sitting with a friend, who was peacefully meditating, she said 'I don't know much about the Incas but they sure picked an awesome spot to build a kingdom'. It was easy to see now why the Incas had used the path we had just trailed, for there was no other way into this lost city.

Aguas Calientes is the nearest main town to the ruins. It is built around a railway station and has taken full advantage of tourism with its many shops, restaurants and bars lining the tracks. Many took a bath in the hot springs - others ate, drank and recalled the unforgettable experience of Machu Picchu.

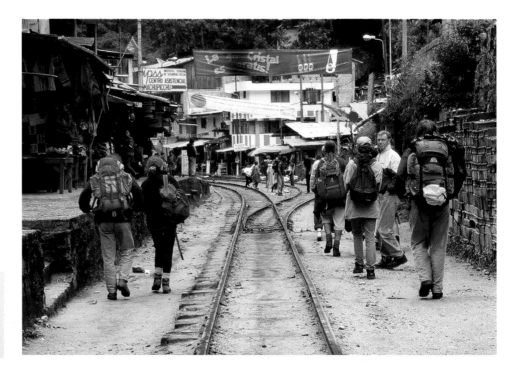

After four days on the Inca Trail in the same clothes they're bound to 'hum' a bit. Professional cleaners were hired which made a change from washing my undies in a hostel wash basin.

Health is always a concern when you're travelling. Sensible precautions should ensure nothing but an upset stomach happens. Whilst treatment is available it's wise to have a general check up before arriving.

Back in Cusco, the markets away from the tourist areas were selling all kinds of produce, goods and merchandise - from padlocks to pantaloons. The guide books warn you to watch out for pick pockets, which can be somewhat off-putting - even a local woman suggested I wear my pack on my front rather than my back. However, this shouldn't be regarded as a deterrent to visit such places, simply as a caution to be aware of your belongings in case opportunists spot the unwary tourist.

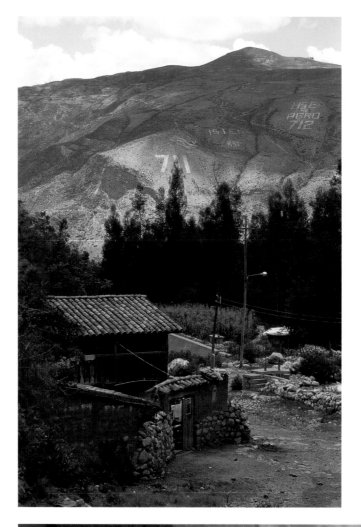

Although I felt the dangers were minimal, they were always on my mind. It's difficult to ignore the military presence, which is on most street corners, and in the countryside where political inscriptions are engraved into the landscape. I took up an offer to stay in Urubamber in the Sacred Valley, and used this as a base for treks into the surrounding hills.

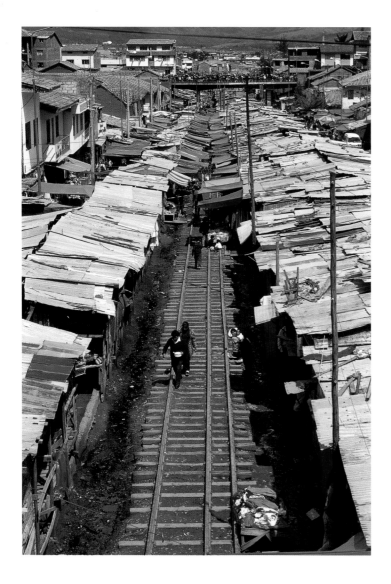

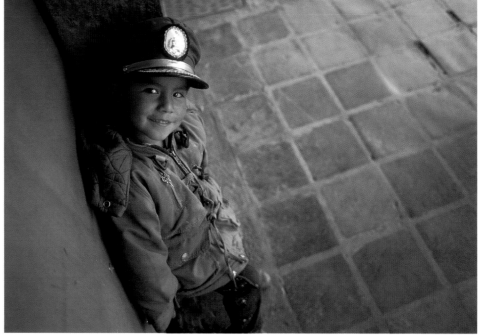

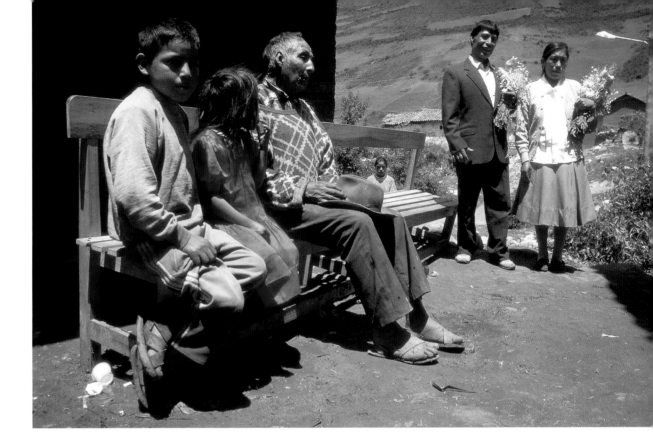

I came across a house filled with people drinking the local brew. I was invited to join them. It was a wedding party and I had arrived at the end of a twenty four hour drinking binge! The newly married couple posed for a picture while Granddad tried desperately to keep awake, obviously suffering from a hangover! The dancing and merriment continued and I left them with the promise of sending them a photo.

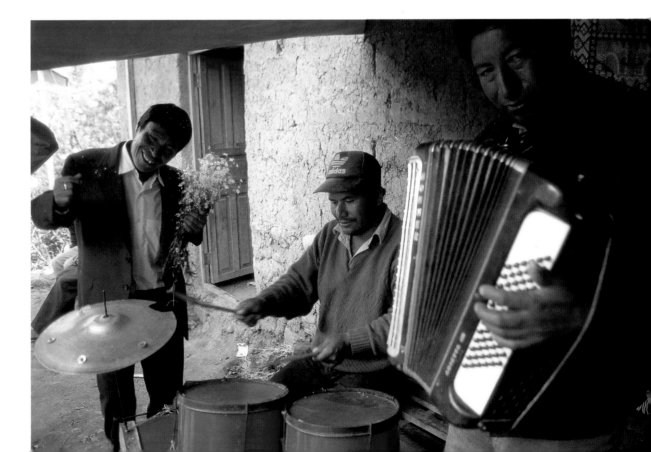

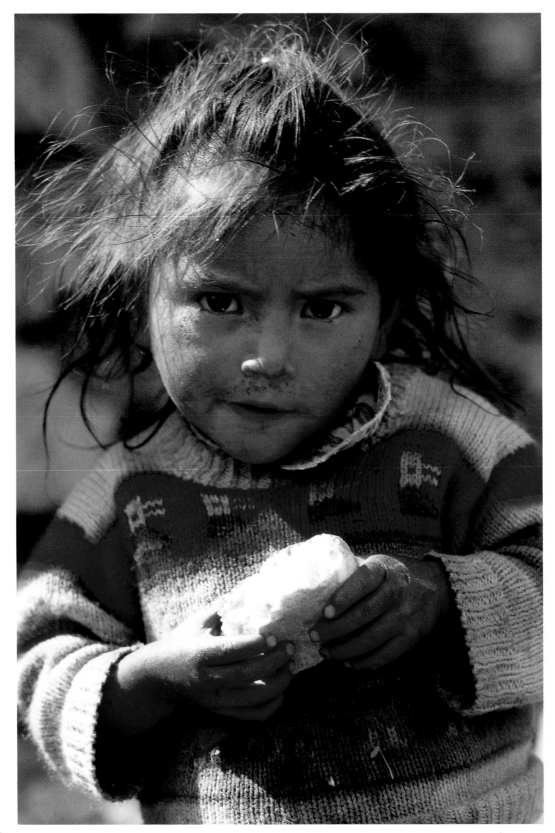

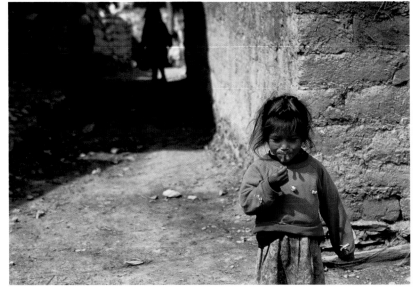

Further into the hills children appeared out of nowhere - be it a bush, field or crumbling shack. I was glad I had taken bread and balloons along with me, as well as a family photo, which on many occasions helped them to accept me.

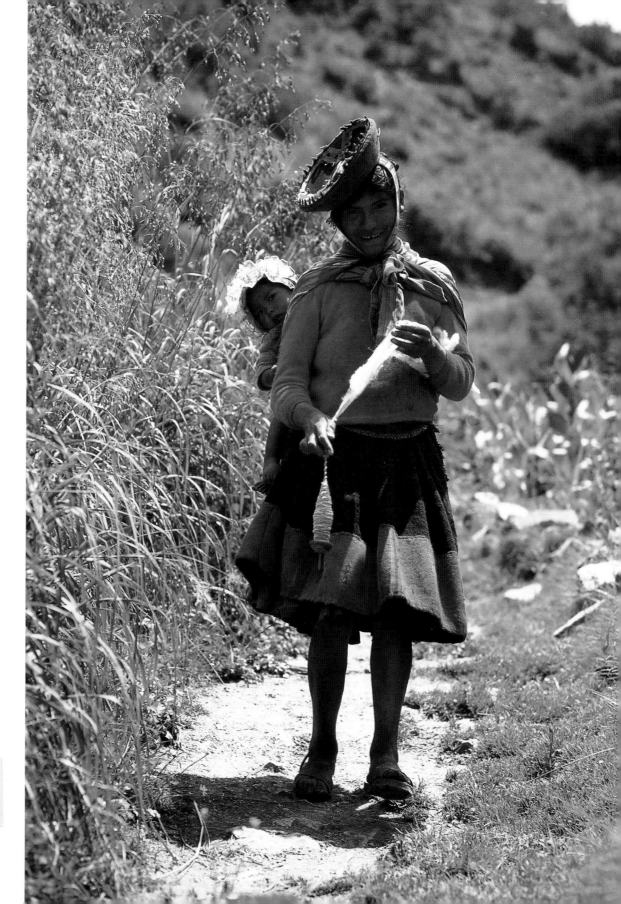

On another day, I visited the colourful village of Ollantaytambol which is renowned for its important ruins and its beautiful bright weavings. Behind most doorways the scene is the same.

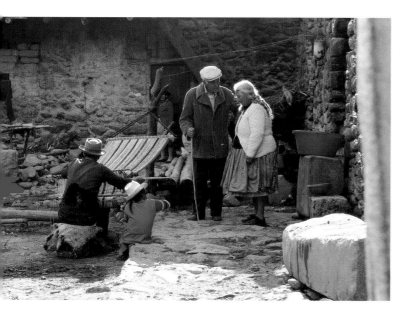

Taking a dirt track into the hills I came across locals passing in the opposite direction on their way to market. Idle hands make for idle minds, but this is never the case here where a few hours walk into town is used constructively.

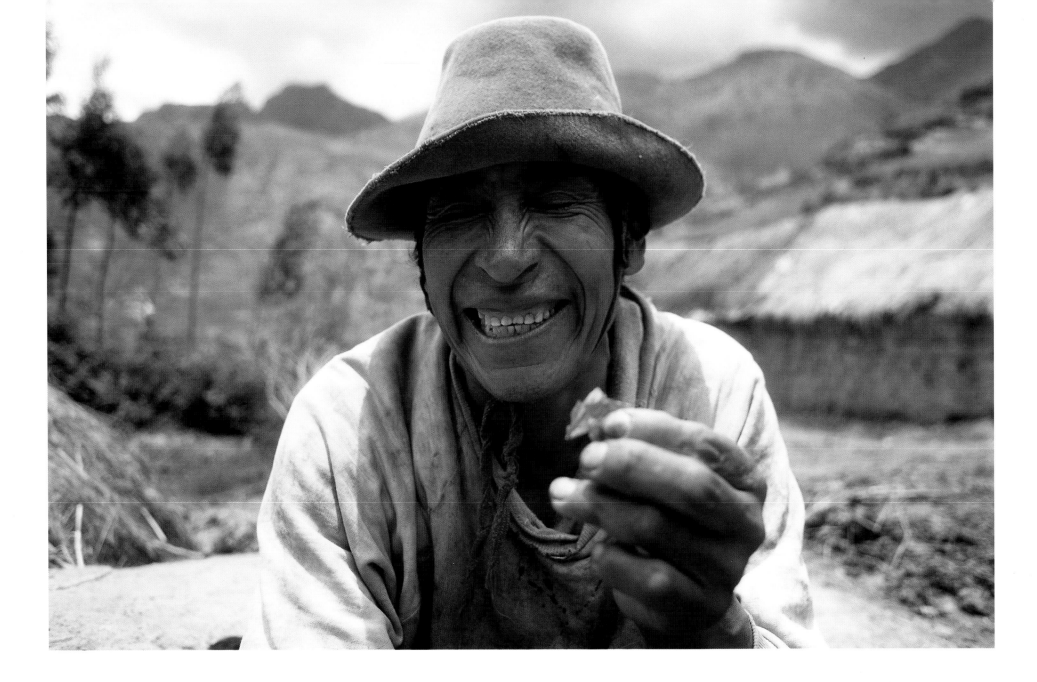

Peru's Coca industry is estimated to be responsible for nearly a third of the country's Gross National Product. Having originally been used by Indians as a stimulant, the market for the refined form 'cocaine' has become massive worldwide. Locals still chew Coca leaves as part of their culture - essential for that extra energy boost and enthusiasm to carry on a days work in the fields.

Captivated by the scenes around me I walked aimlessly into the hillside. Everyone I met was busy weaving and welcomed my curiosity. It appeared to be a place which time had forgotten, and where everyone lived so simply. Unaware of the distance I had travelled, time suddenly caught up with me. I headed back with four hours hard walk ahead and in a pair of sandals made from old tyres. I got back just before dark, dehydrated, famished, exhausted and unable to walk another step on my blistered feet. I spent the next two days recovering in bed!

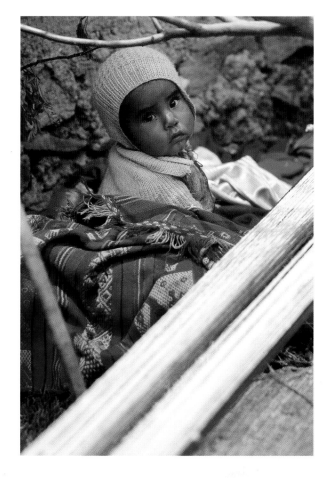

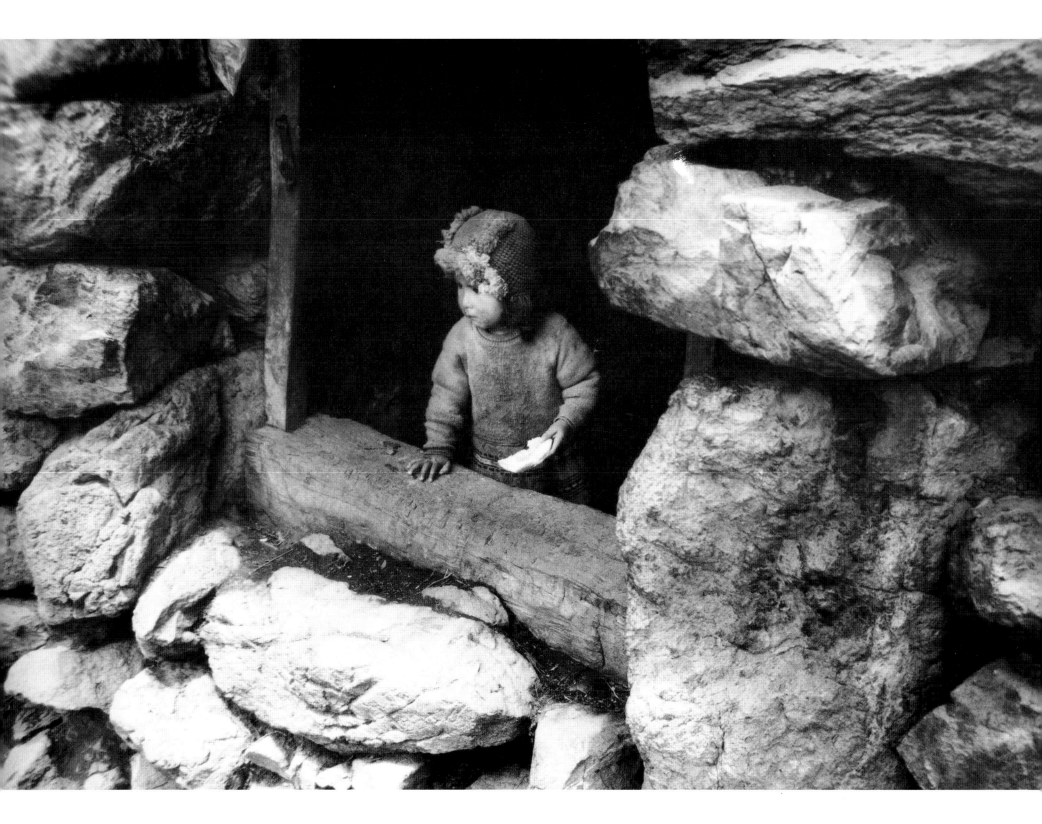

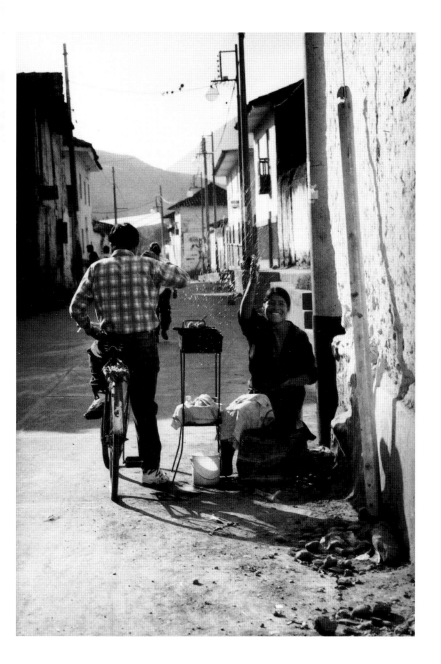

I ate many meals from the street in the small and friendly town of Urubamber. The food is cooked freshly and in front of you, but the standards of hygiene aren't high and it can have unpleasant repercussions. The food is dirt cheap, traditional and generally tastes good. It is also far more interesting having direct contact and closeness with the locals rather than sitting in a restaurant eating pizza with a menu for company.

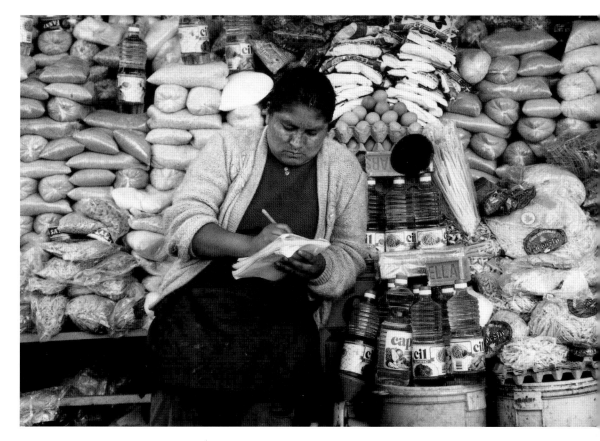

Stock checking must be a nightmare!

For a week I lived on the outskirts of town with a German woman and her two children. She was in the final stages of building a home for herself and her family. Leonie has lived in and around Peru for the last eleven years. She'd had a brutal marriage to a Peruvian and had been forced to push him out, and had picked up the pieces whilst trying to divorce him. She had single handedly built a house, using what her land had provided for materials - trees for structure and doors, mud, water and stones for walls and floors. Anything she didn't have such as hardware and tools were bartered for with the fruit from her orchard and trees from her wood.

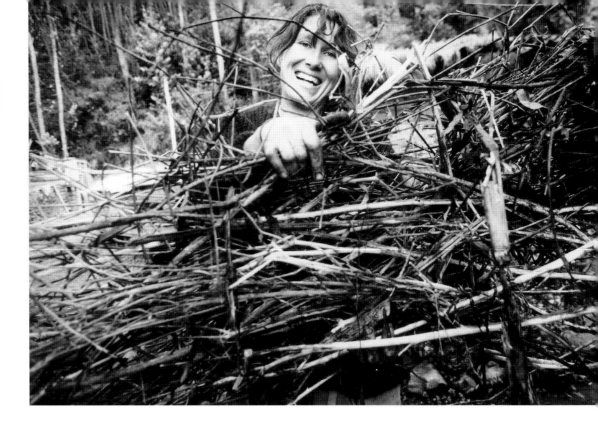

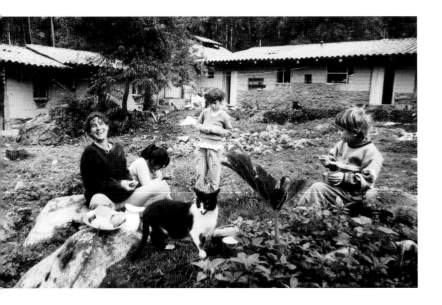

As a result of living in the jungle for a number of years Leonie had picked up a wealth of knowledge which included the understanding of plants and their properties. Her goal, once the mammoth task of her house was complete, was to farm organic vegetables to sell to the restaurants in Cusco, and to make creams, oils and ointments from her garden of herbaceous plants. Her children helped her sporadically, in between playtime. They were born (self delivered) and brought up in Peru. Leonie is known as an experienced midwife for any needy neighbour.

She is probably the strongest woman I will ever meet. Her life story would make a great novel. The emotional scars of an abused childhood were followed by desertion by the father of her first child, and the subsequent struggle to bring up that child alone in a country which politically and socially rejected her.

From living in a refuge for women and children, Leonie took off to Peru with her baby, in search of a new beginning. But life was not easy in a country where you are quite obviously different to the natives. She knew no Spanish, but now speaks it fluently, as well as Quechua and other dialects. She met and married a Peruvian and before she knew it, she had five mouths to feed instead of two. They spent years roaming the country. They lived in a variety of places including shanty towns on the outskirts of Lima, where the water was delivered by lorry and rationed!

Leonie has incredible optimism and her whole purpose in life is to provide for herself and her children. She wakes at five am every morning, works all day as well as cleaning and cooking and spending time with her children, and sleeps disturbed knowing there's a never ending list of chores to be done. Her dream is to wake up one morning and laze around her swimming pool (which she has yet to build) and write a long overdue letter to a friend! Among other jobs she has worked as a translator, and even studied and passed an intense course to be an Inca Trail guide for German tourists. She did this to prove to herself she could do it, but she has no intention of using it to exploit tourism in the area, as she knows first hand the damage this has already caused. Her land is situated beneath a historic Inca site - there has been interest to exploit this and put it on the tourist map. The only access to it is over her land and she strongly believes it should stay untouched.

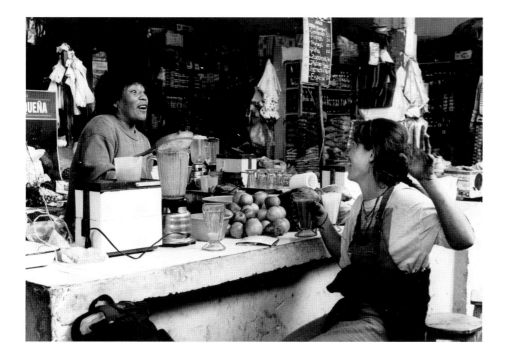

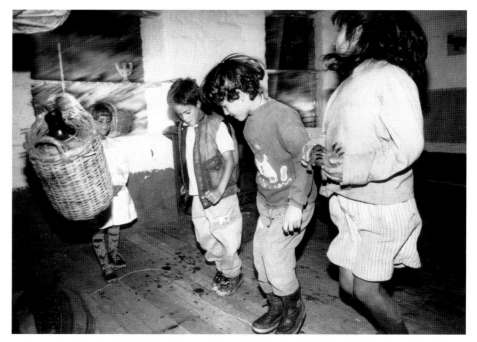

Nights were spent playing musical chairs, spin the bottle, or dancing and singing together.

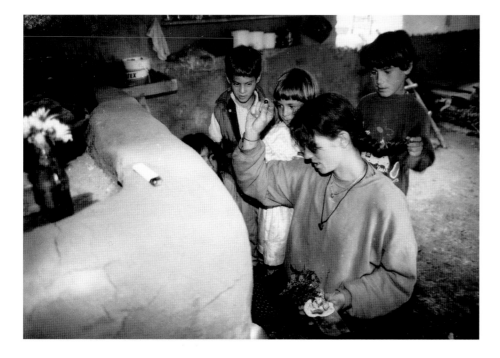

Leonie's kitchen is equipped with a hand built and designed clay oven. After two years of cooking outside in impractical conditions, she finally has shelves to separate her spices and hang her colanders. This important moment in completion was marked by a ceremony of thanks and protection. Everyone gave something personal, placed it on the fire and made a wish. My offering was an unused photographic film. A lock of hair was taken from each head, and flowers and herbs from the garden were burnt in the first flames.

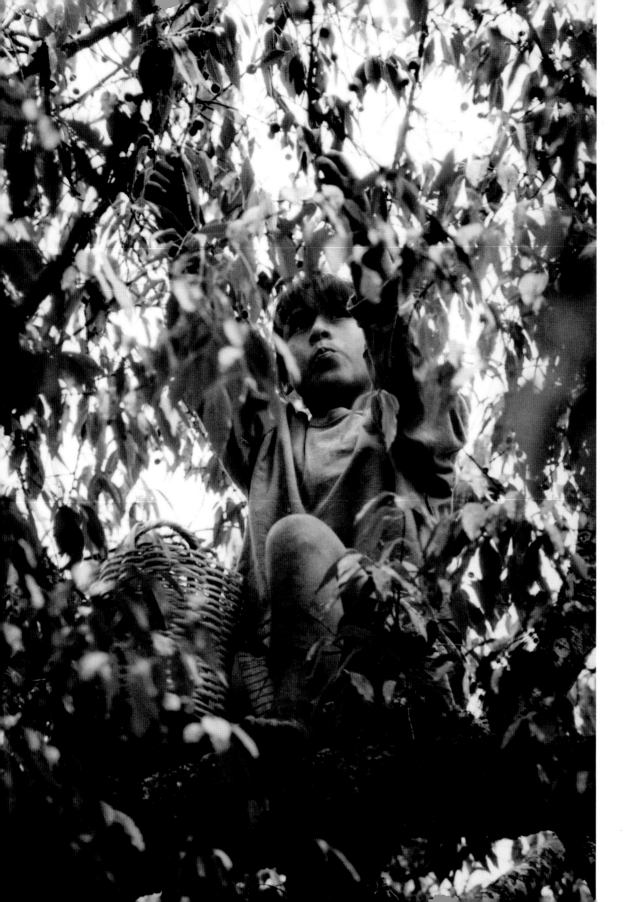

Leonie occasionally employed neighbours to do jobs that she didn't have the time for. She survived on favours and bartering time for produce. She also had the help from the daughter of a friend who worked with her in exchange for a bed, food and a little pocket money.

An extended invitation to a local's birthday party was taken up. The other guests were already pissed by the time we got there! Chicha, the local concoction of fermented corn or strawberries was served up in gallon jugs and thrust into our hand on arrival and toasts were continually made around the room. These reminded me of a drinking game I had played in my teenage years. The 'get pissed quick' game consisted of alternate partygoers spotting someone not drinking and on raising their glass, roar 'salute' which reminds them to drink - it would be rude not to drink in reply and difficult not to get drunk. Our jugs were refilled every two minutes!

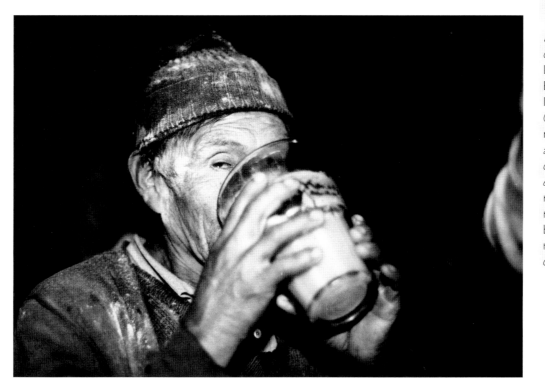

A playful fight of throwing coloured flour broke out, and a cloud of snow covered everyone in the room. One old lady had a handful smeared into her face by an over excited son-in-law and she lashed out at him for his disrespect. Once the dust had settled and another round of Chicha was drunk, the tone deaf antique stereo was turned up and welcomed with dancing. I was glad of the dancing lesson I had had from Leonie the night before! The traditional Quechuain music from the region was accompanied by a complicated jig. Thankfully I didn't make as much of a fool of myself as I could have!

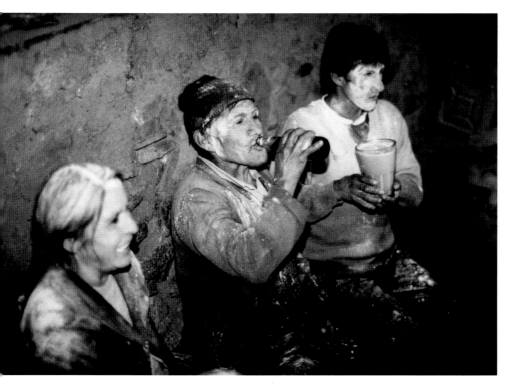

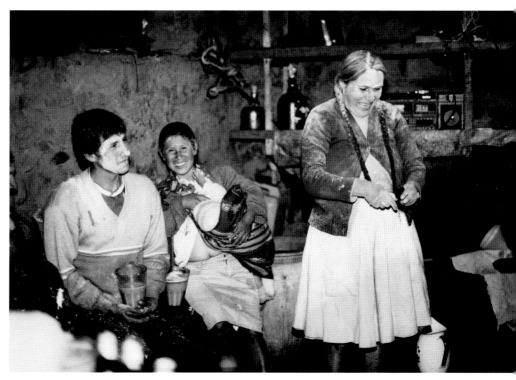

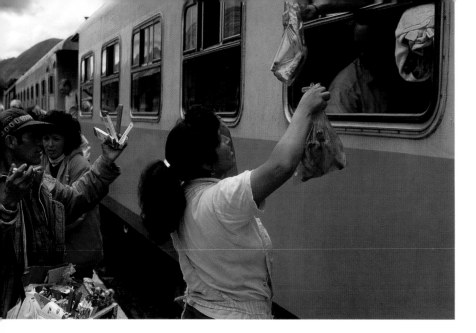

I returned to Cusco to catch the early morning train to Puno, which was a journey ten hours south - longer than the bus trip, but worth it. The track cut through valleys with spectacular views on either side. The stations we pulled into were bustling with locals desperate to sell Alpaca hats and scarves as well as a variety of home cooked snacks. It was relaxing on the train and I spent the day playing cards, chatting, writing my diary and gazing out of the window. The calm atmosphere was suddenly broken by one of the typical horror stories I had heard of, actually happening. A young boy came into our carriage and stole an expensive rucksack and camera - he was in and out in seconds leaving our carriage in a state of shock.

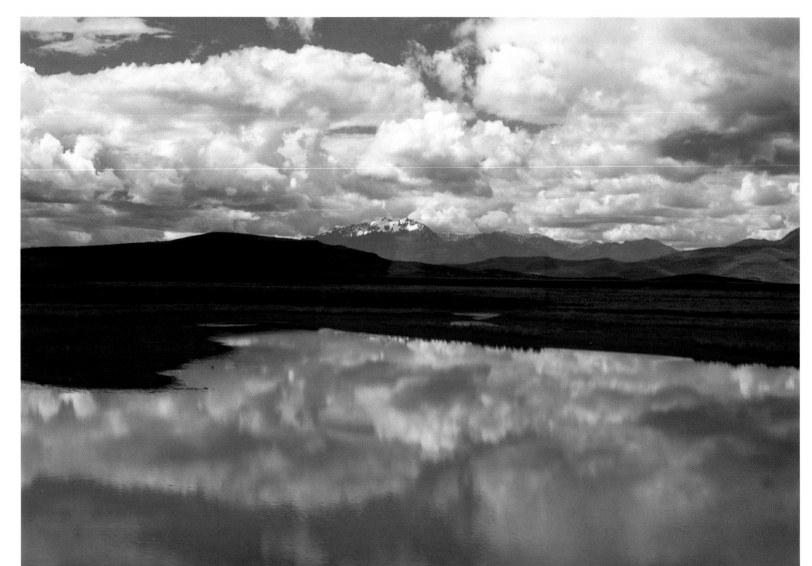

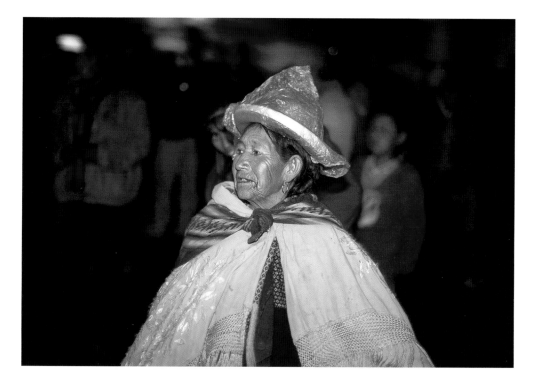

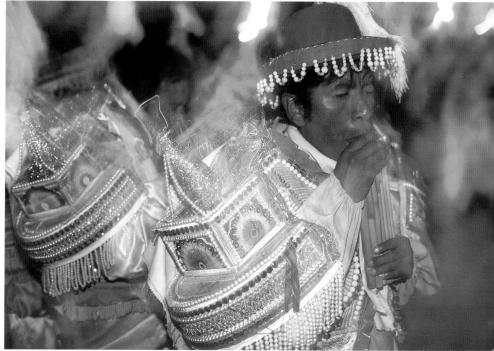

Puno is the crossroads for people en-route from Peru to Bolivia. I timed my travels to fit in with the Fiesta de la Candelaria which is held in the second week in February. Despite the weather, the celebrations carried on in between showers and throughout the night. Puno is the folklore capital of Peru and the event, which had run for almost two weeks, was highly commercial - different to the regional festivities I had stumbled across off the beaten track. Flamboyant costumes, musicians and dancers all took to the streets - bringing the normally dull town to life.

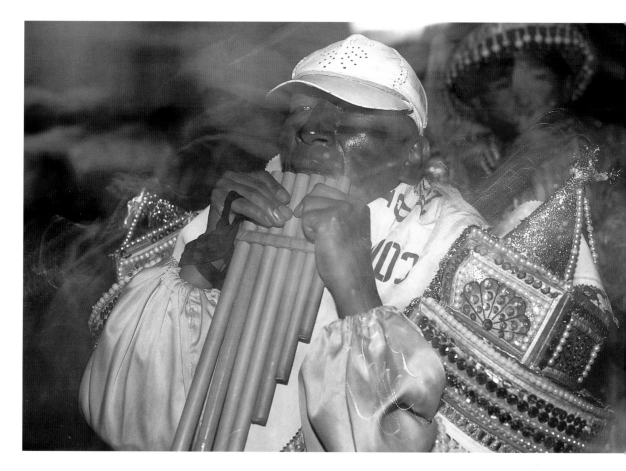

Pressure from over-enthusiastic touts to take a tour made me even more determined to visit the Amantani Island on Lake Titicaca by public transport. I had decided not to stop at the Floating Islands on the way, having heard off-putting stories. When passing them I was glad, for it looked like a zoo with hordes of visitors arriving in private chartered speedboats to glimpse something unusual and almost extinct. Although the Islands used to be inhabited, the locals now only spend a limited time there to sell postcards and hand made reef dollies. Once the day's tours had finished everyone returned to the mainland.

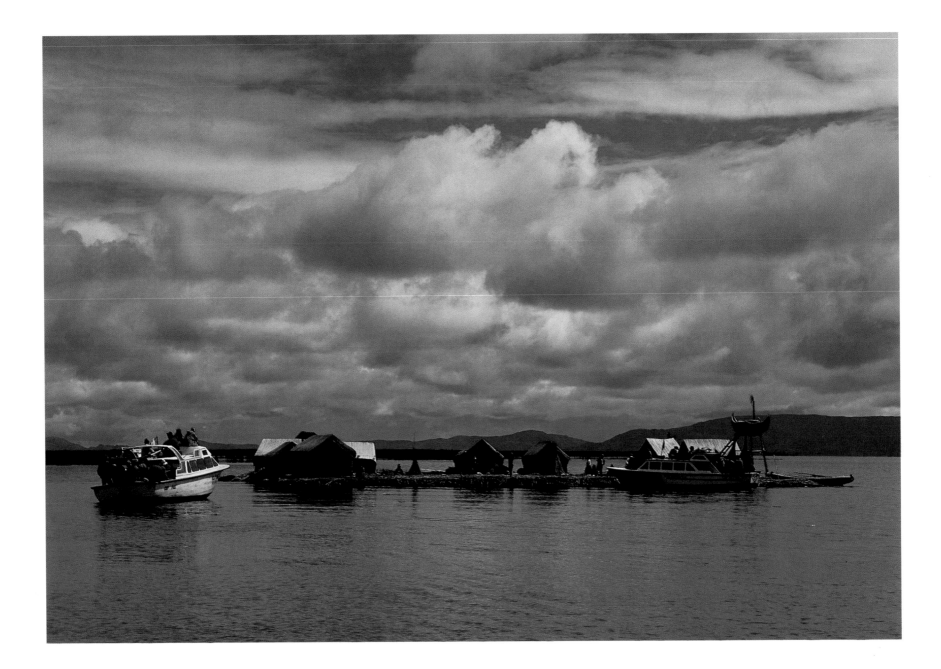

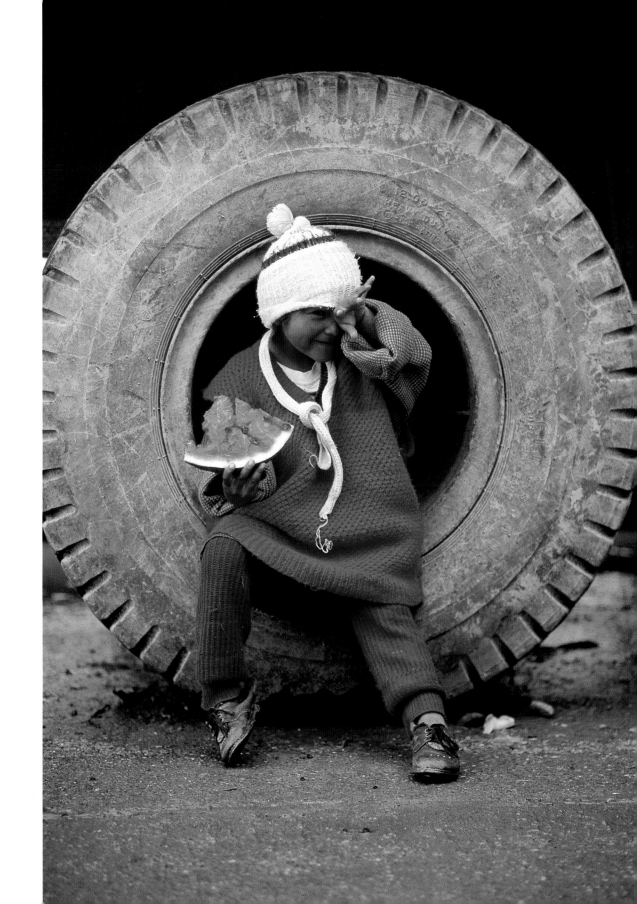

The markets on either side of the border were relaxed and the children were happy to eat what their parents were selling - crossing should have been a simple task. Unfortunately I couldn't find my entry visa and was told I'd have to return to Puno to purchase a new one. The thought of adding another six hours onto my journey was a nightmare but fortunately the problem was solved with the exchange of a few dollars. It was a lesson to keep my papers in order.

bolivia

Bolivia is a country I'd always wanted to visit as other travellers had raved about it - its friendliness, as well as its diverse cultures and landscapes gave a feeling of being old and reliable. Despite the political strife there seemed a mysteriousness about the country. There are more direct Indian descendants here than in any other South American country and this gives deep and solid roots for cultural evolution.

There is a huge diversity in the geography - with the peaks of the Andes and deep jungles. The topography gives a wide ranging climate with a prevalent rainy or wet season (November to March) covering most of the country. Travel is cheap as is the cost of living. A jungle tour in Peru costs anything between US$60-100 per day and the equivalent in Bolivia is between US$30-60. Everything else is relative - food, accommodation, transport, souvenirs which are all almost half the price of those in Peru. Bolivia should be an independent travellers heaven!

The summer is the rainy season, so I had chosen a bad time of year to be there, but I continued in the hope that I might be lucky and get a dry spell. Language still made me lack confidence about being able to interact and hang out with the locals - limiting my ability to live, work or learn about their lives in the way I would have liked.

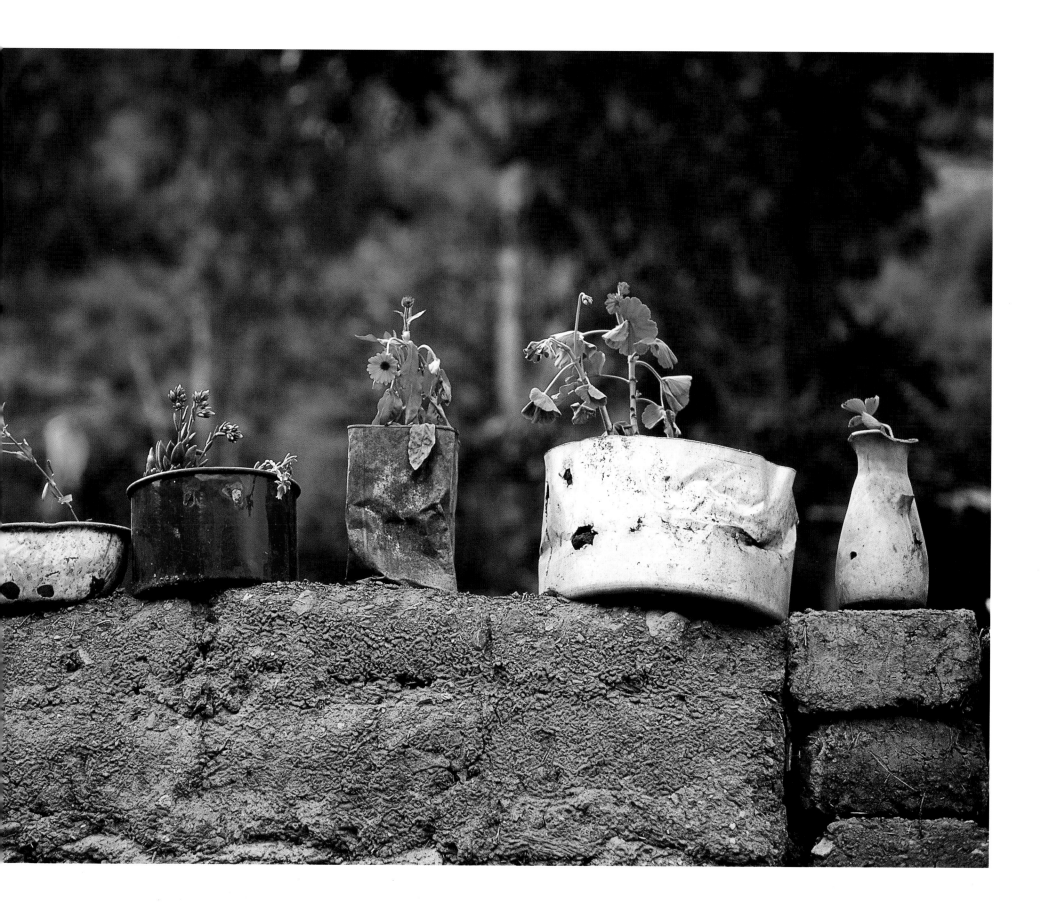

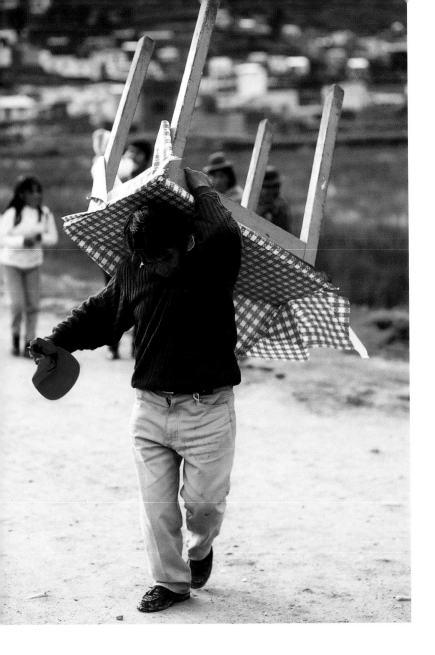

We arrived in the sunny town of Copacabana to witness a regional carnival in full swing, and having checked into a hostel with stunning views over Lake Titicaca, we absorbed the festive atmosphere. The procession headed out of town with everyone following, taking everything with them, bar the kitchen sink.

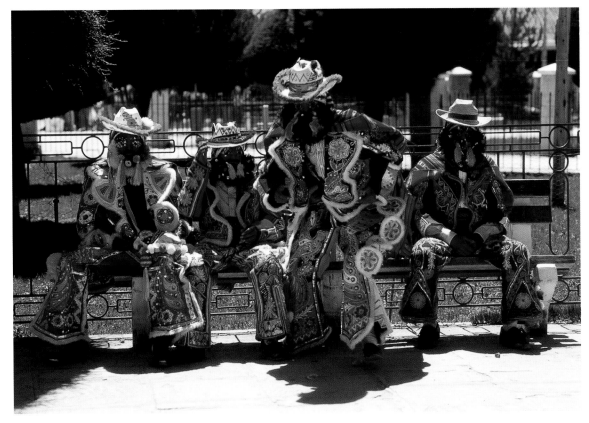

It seemed that I had stumbled into the South American carnival fever and everyone was either celebrating, had celebrated or was about to celebrate. I had been told that there were national and regional carnivals as well as local ones where the village have their own reason for worshipping their own patron or saint. It was interesting to compare them.

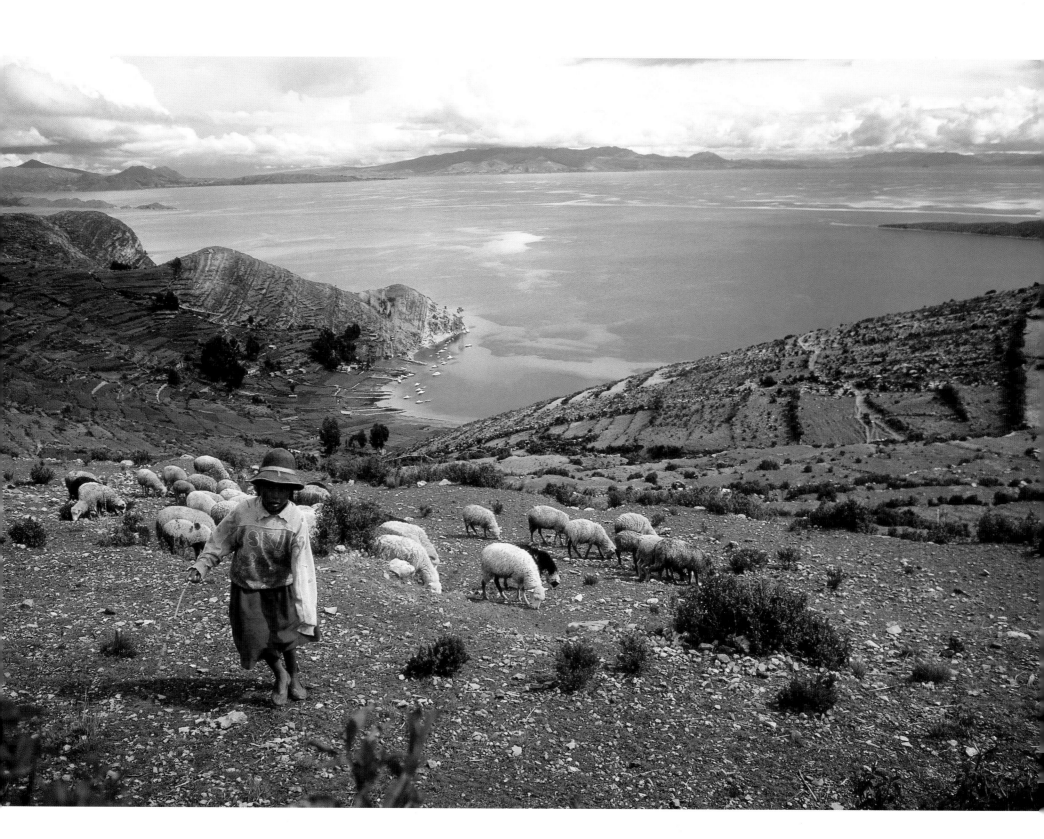

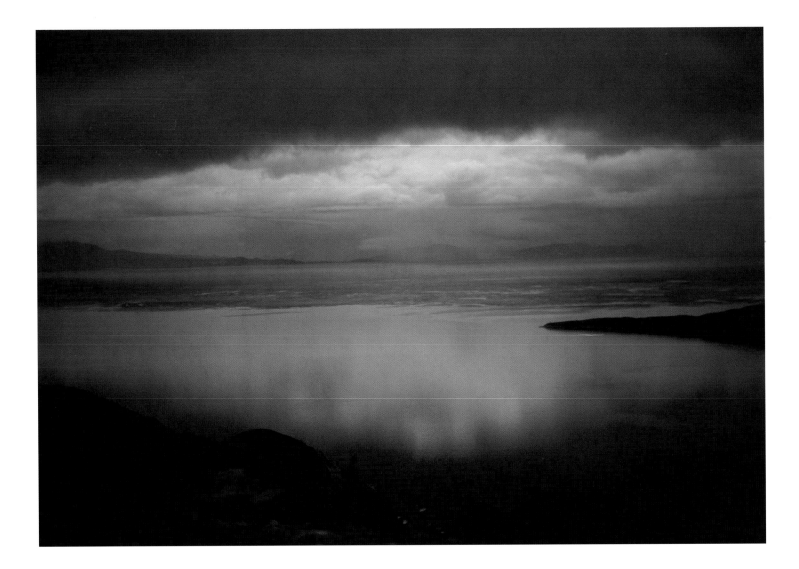

I met up with an Argentinian (who was also en route to La Paz) and we decided to visit the sacred Isla del Sol (Island of the Sun) together. This is believed to be the site of the Incas' creation and the birthplace of the sun. Our boat dropped us off on the north side of the Island where we were unintentionally greeted by yet another carnival procession. We followed a tour group to some ruins before splitting and taking a track to the south side of the island where there was a hostel. We were told by the boatman that the trek would take us two and a half hours but in fact it took us four. We stopped sporadically to absorb the mystical and incredible views over Lake Titicaca (the highest navigable lake in the world). It seemed strange to be so close to the clouds as we overlooked the lake. It was deadly quiet except for a few grasshoppers at our feet. On the highest peak you could certainly feel the pressure on your lungs with the altitude at nearly four thousand metres. Breathing became almost suffocating. Our hostel was still in the process of completion, but had wicked views. We sat together putting the world to rights while watching an electric storm light up the horizon.

La Paz is Bolivia's largest city. As the bus entered through bleak and poverty-stricken suburbs I became concerned. This couldn't be the friendly place I had been told about, and it certainly wasn't the commercial metropolis I'd read about. All of a sudden, it was as though we had reached the end of the horizon. The ground opened up in front of us revealing La Paz. We entered the deep canyon and slowly descended into a massive expanse of new surroundings. Having had the chance to look around La Paz, it seemed to me to be a place where travellers have the chance to recharge their batteries, to consider and to arrange onward journeys, to 'shop 'til you drop', to 'score' cocaine or to take in the many sights that the city has to offer. The central area around the San Francisco church was heaving with markets, traffic and people. Andean folk bands were playing, a protest had gathered, which was difficult to understand because of my lack of language, and in between the flocks of tourists and the locals going about their daily routines, shoeshiners hassled for business every few feet.

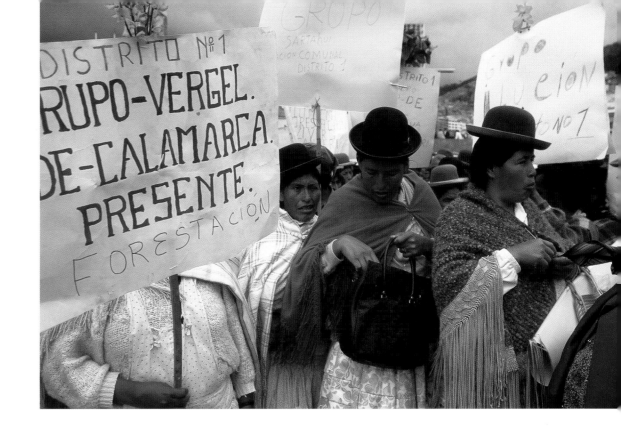

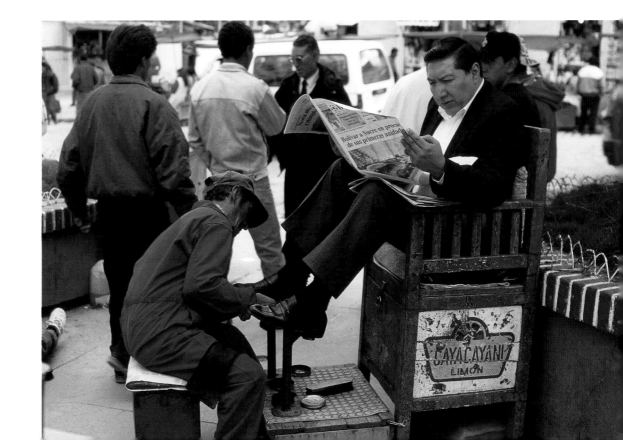

In amongst the tourist markets, hidden on a back street, I came across the Witches' market. The array of ointments, remedies and good luck charms on display included ground-down cats claws and llama foetuses. It was interesting but stomach churning and even the sweets for sale looked sickly and off-putting.

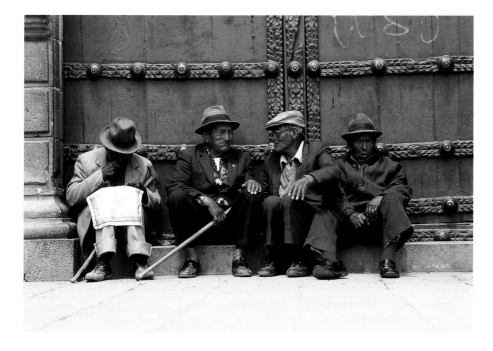

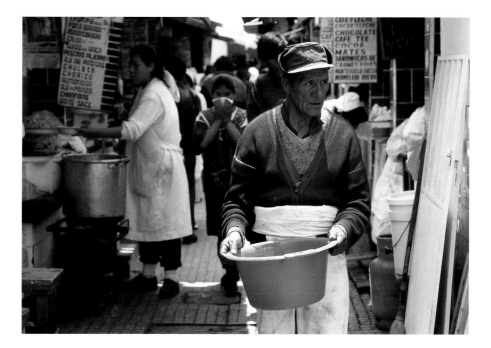

It was a great place to people watch or sample the local food markets which are both traditional and cheap. The choice available is mainly limited to meat, but searching through the chaos of different stalls it is possible to find simple food such as corn on the cob or fried fish and rice. Fruit juice bars were also an alternative, the delicious banana shakes were a meal in themselves. I spent two days in La Paz, trying to decide the best route to take. Because of the rain, the tourist offices put me off every idea I thought of. They told me Bolivia was experiencing its worst wet season for four years. I'd planned to go to the jungle but was informed that even if I got there (which was unlikely) tours weren't running because of flooding. The roads over most of the country had become hazardous disrupting public transport services. Despite all this I decided to continue south to Potosi.

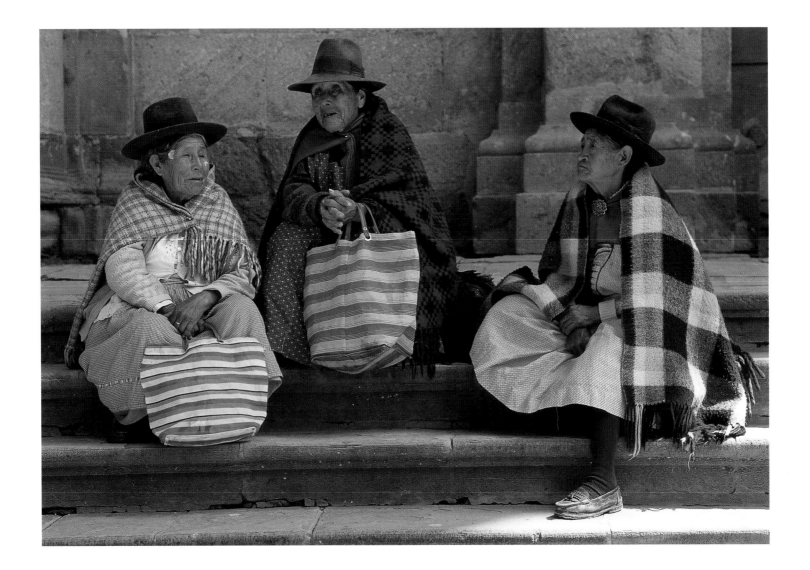

Taking the night bus from La Paz I arrived in Potosi early in the morning. It is the world's highest city, and the weather changes from sunny and hot by day to freezing temperatures at night. Towards the end of the eighteenth century Potosi was the wealthiest city in Latin America. Walking around, you can see obvious reminders of this. Although it was regarded as a city it seemed more like a charming town. I warmed to the friendly locals and the impressive colonial architecture in the centre. Exploring with interest I was drawn into the back streets with their whitewashed buildings and cobbled streets. As in most towns the main plaza was the central meeting point for travellers and locals alike. Many took advantage of the good weather and sat around for hours on end chatting and catching up with the gossip. Potosi's wealth came from mining silver and the main reason for visiting the town is a trip down the mines (which are due to be closed at the end of the century).

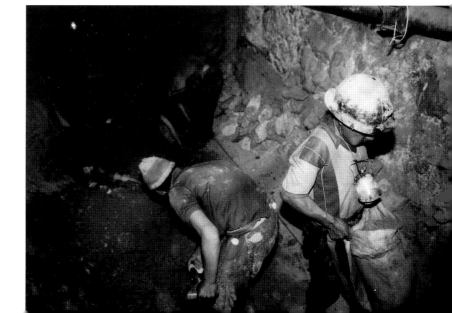

The guided tours down the mines are shocking to say the least. Before descending, we were taken to the miners market and urged to buy water, cigarettes and dynamite as gifts for the men at work. The working conditions haven't changed since the seventeenth century and all work is done by hand with primitive tools in stifling temperatures. Some begin work as young as eight and are lucky to reach thirty five, and all for three dollars a day! Our guides, who were ex-miners, had realised the dangers of working in such horrific conditions and now exploit what they escaped. Two girls with us had to abandon the mission through fear of claustrophobia while within a hundred feet of the entrance. It was difficult to breath and impossible to see anything when bent double in the pitch black muddy, airless tunnels with only a small gas light for illumination. Our water was gratefully received by the miners, who carried on with their work loading endless sacks of rubble on their backs. Our gesture didn't make us feel any better about being there and watching their struggle.

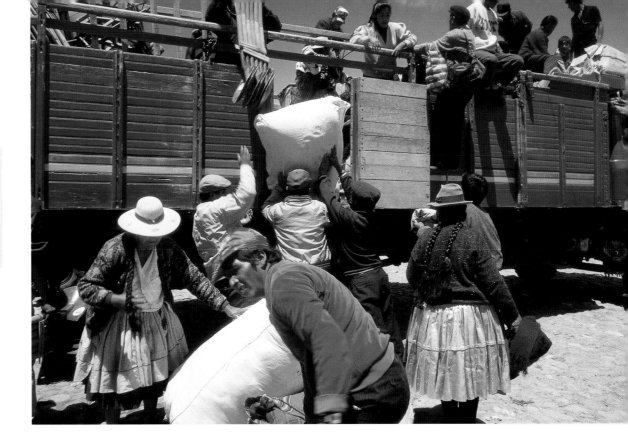

I had wanted to visit the Salt Plains near Uyuni, but the tourist police had stopped all tours because many had been stuck there for days. I decided to leave Bolivia and head over to Chile. During my travels I had discovered various methods of transport not mentioned in guide books which were cheap and often incredible adventures - open to the elements with unobscured views. They inevitably involved asking around and waiting for hours.

However, this time I chose to take the bus as the public transport system in Bolivia is far less complicated than Peru, as all the companies have one central terminal, and the buses leave regularly and in all directions throughout the day.

Wanting to be sure of fine weather I headed over the border via Charana to Arica, Chile's most northern city. We stopped several times for some refreshment on the dusty highways which served as the cross-roads for commuters who were passing in all directions.

63

A rica was a rest from travelling. Although the beach was nothing to write home about, being at sea level, I was able to breathe normally and get a suntan. The airline I was travelling with went bankrupt and I had to return to Lima to exchange my ticket for a new one. In order to save a three day bus journey, I flew from Tacna (just over the Chilean border in Peru) to Lima. From Lima I decided to travel onwards to Ecuador and caught a connecting flight to Trujillo. It cost me $100 but with the time saved, I felt it was worth it.

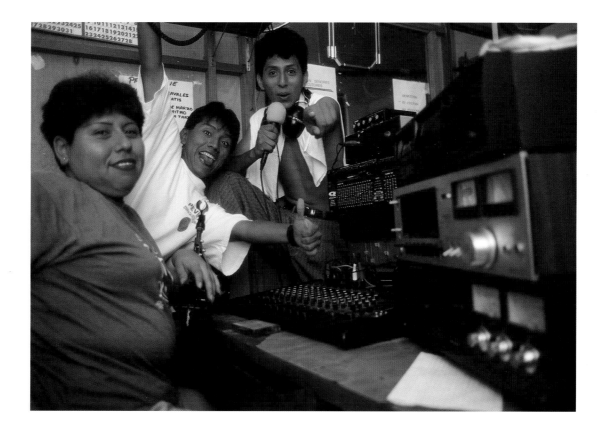

I stopped to visit my friend who worked for a radio station in Trujillo, who invited me to stay for a few days. My chance of fame on the station, which had over a million listeners, lasted just over a second. All I could say in the excitement was 'Hola'.

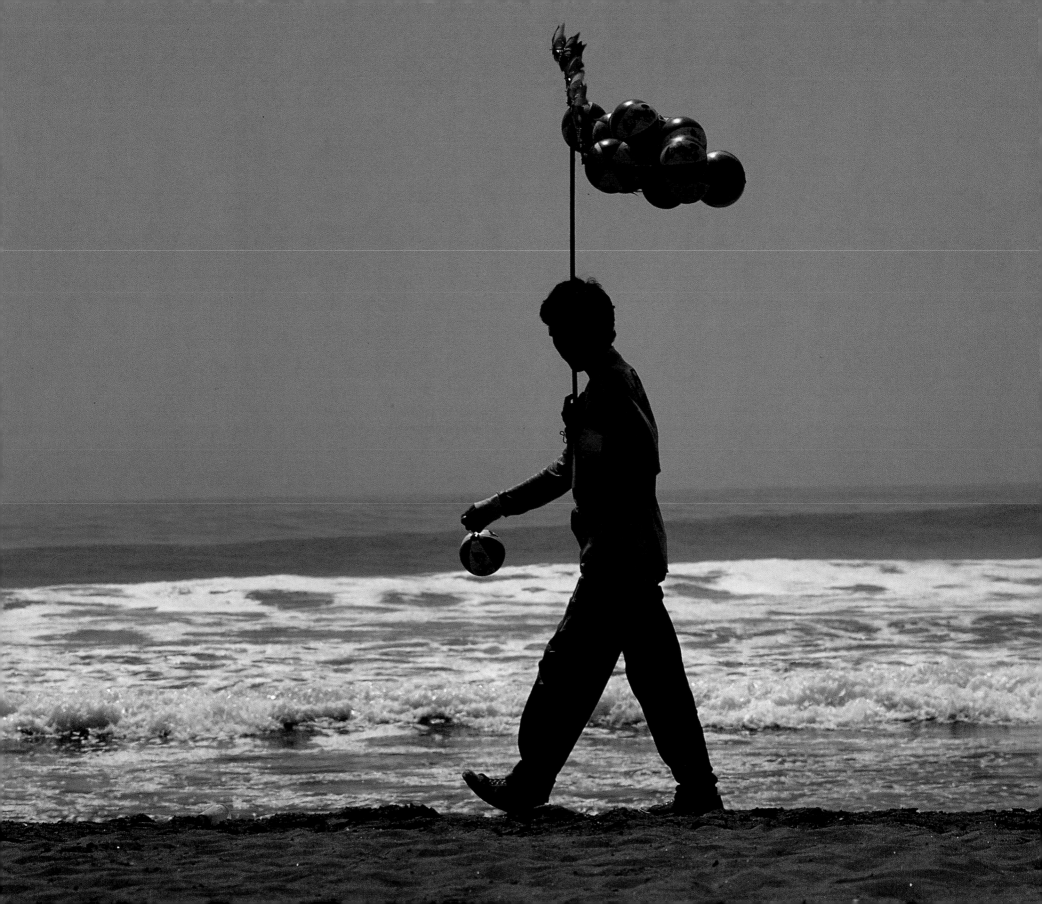

I took advantage of the nearby beach in Huanchaco to improve my suntan. I was approached by a guy who I thought wanted a chat, but I soon realised he actually wanted a little more when he became over friendly and started to touch me. I started to panic but fortunately a girl nearby joined me and threatened to call the police unless he left me alone. He was drunk and a few threatening words sent him scurrying off. All around me vendors trawled the length and breadth of the beach (the best beach in the area) selling ice creams biscuits and balloons. This incident heightened my senses to the dangers of travelling alone but in general I felt safe here.

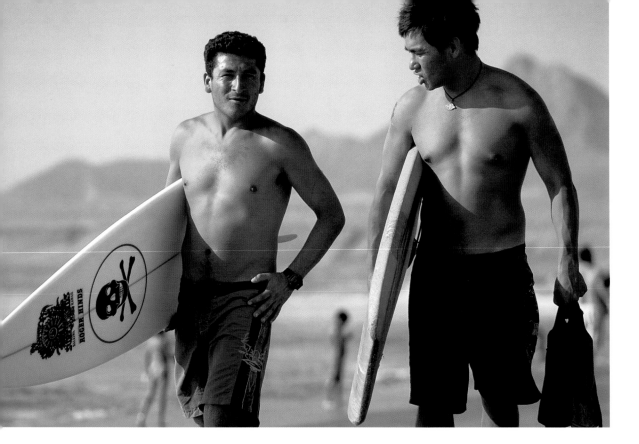

Surf, sun and sea attracted a young crowd to the west shores of Peru. Behind the wash of the waves (the best in Peru), contemporary music roared from the bars and cars lined along the esplanade.

Being a fish eating vegetarian I was in heaven in Huanchaco! Ceviche, a local dish made from raw marinated fish, became my staple diet. The fish, which is fresh each day, is caught from ancient sea-going rafts which are a distinct trademark of the area. These boats are made from tortora reeds tied together and are called 'Caballitos del Mar'.

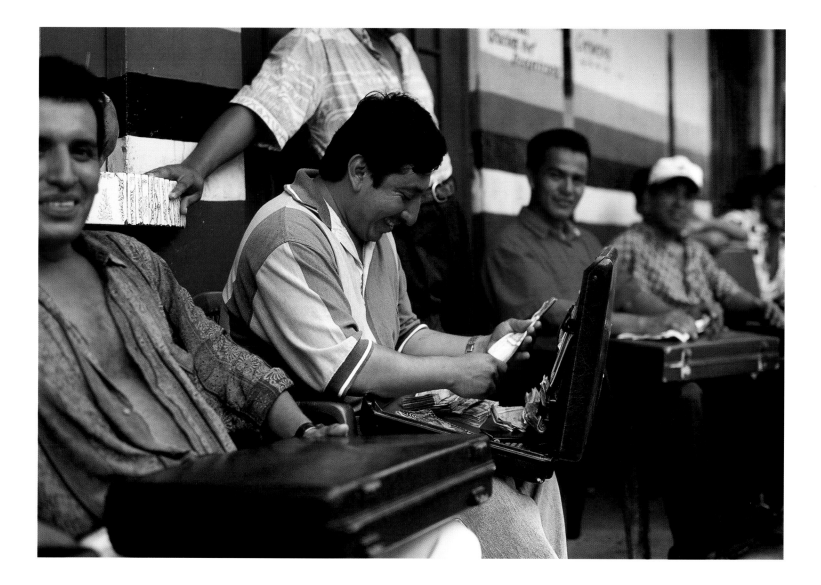

The border into Ecuador was busy with scam merchants, fraudsters, taxi drivers and money changers, whose calculators were rigged to read low, all happy to rip off the unwary traveller. Luckily I had managed to exchange my Peruvian money for Ecuadorian money with some tourists who were travelling in the opposite direction. It is always confusing working out the different currencies, and having been through four countries in less than two months, my head was in a spin with calculations.

ecuador &
colombia

It's difficult when you're given conflicting opinions about new countries. I was almost put off Ecuador by one guy who said it was boring, but other encounters with travellers urged me to go. It's a small 'touristy' country, brimming with personality and things to see and do - from the jungle, to the mountains, to the sea. The equator cuts through Ecuador, which is where its name originated in the early eighteen hundreds. It has two seasons, wet and dry. The size of the country, which is a fifth of the size of Peru, makes places easily accessible, so instead of days on buses it is more likely to take hours. One of the main differences I noticed between countries is the transport. Ecuador was even better than Bolivia - I found there was a bus waiting to leave within an hour to wherever I wanted to travel. My first impression, as I took the bus from the border town of Huaquillas to Vilcabamber, was of lush vivid green vegetation. The military presence was far greater than in the countries I had come through, and I had to get off the bus a dozen times to have my passport checked.

There are a number of reasons to visit Vilcabamber: - to recover from your travels by lazing in a hammock surrounded by some of the most awesome scenery; to trek on horseback or foot; or to sample San Pedro, a cactus with hallucinogenic qualities. Many make the trip to Vilcabamber with this latter experience in mind. I shouldn't have been surprised at it being available from the guy at the tourist office! The first hurdle is drinking the substance. Its vivid green colour and revolting smell are enough to deter those with a weak stomach. For those who try it, most will either feel nauseous within an hour or vomit. I managed to keep mine down and, after two hours was experiencing an abnormal but pleasant sensation - multicoloured traces were left before my eyes by flies or movements of the hand. The mild trip lasted twelve hours and I truly felt part of nature on a surreal scale! Others told of more intense trips lasting twenty two hours and experienced visuals including lemons on a tree twisting around and smiling at them!

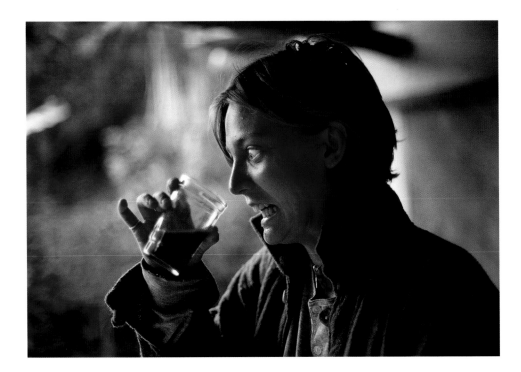

Vilcabamber is known as the 'valley of longevity' - until recently the town was full of pensioners over one hundred years old. The reason is not known as to why people of the valley live to such a great age, but assumptions have been made that it is a mixture of the near perfect climate, the altitude and the natural spring water from the hills (which is now marketed and sold in cardboard cartons advertising its qualities). I made it my mission to visit the oldest man in town. Welcomed into Albertamo Roa's house, his wife told us he was one hundred and twenty six years old. They had married when he was fifty and she just fifteen and have been happily together for seventy six years. When we arrived, Albertamo was sitting in the corner separating peas from their pods and when we left he hadn't moved. Although blind, deaf and unable to walk, his complexion was marvellous for his grand old age. We thanked them with a pound of cheese.

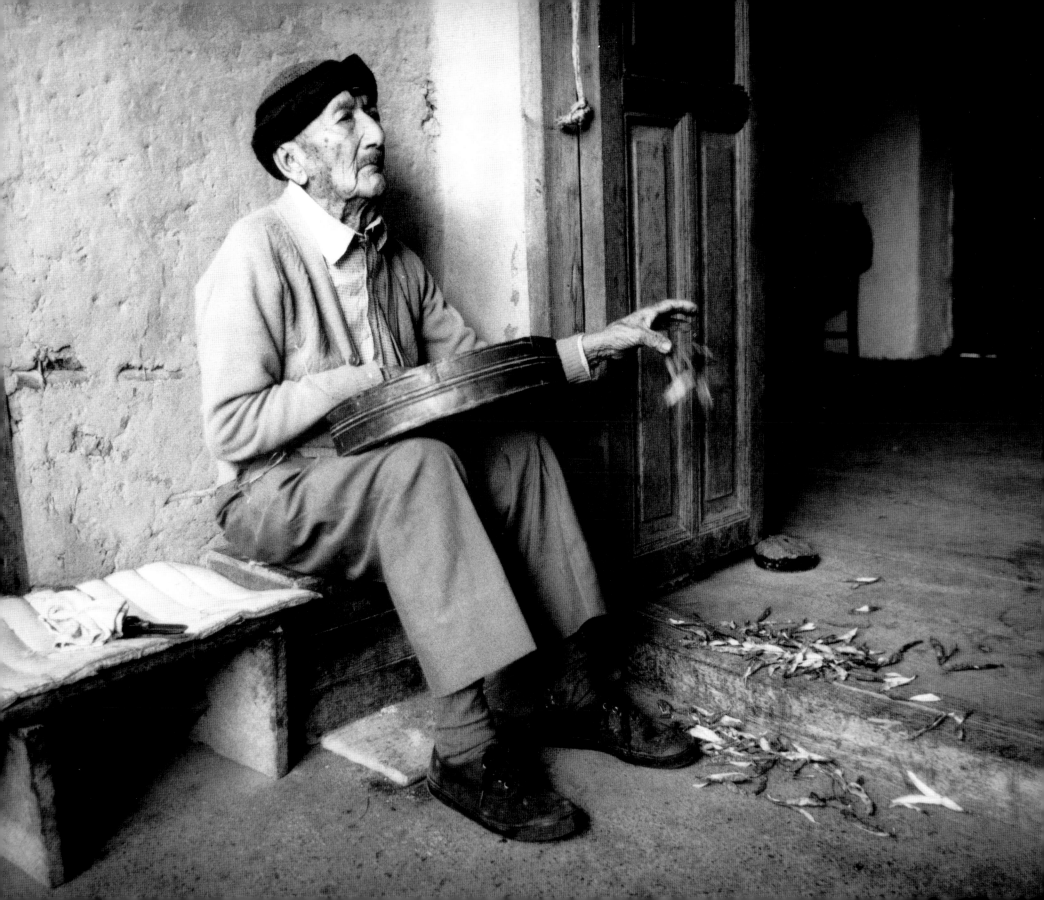

The pace of life is peaceful and, although many travellers come here, it is an escape from commercialism. I decided to stay in a cabana out of town which was surrounded by the most awesome views. It was a magical place, where time stops still, as do the many travellers for a few days. The lack of amenities mean you have to make your own entertainment, just as the locals do in and around the small and friendly village.

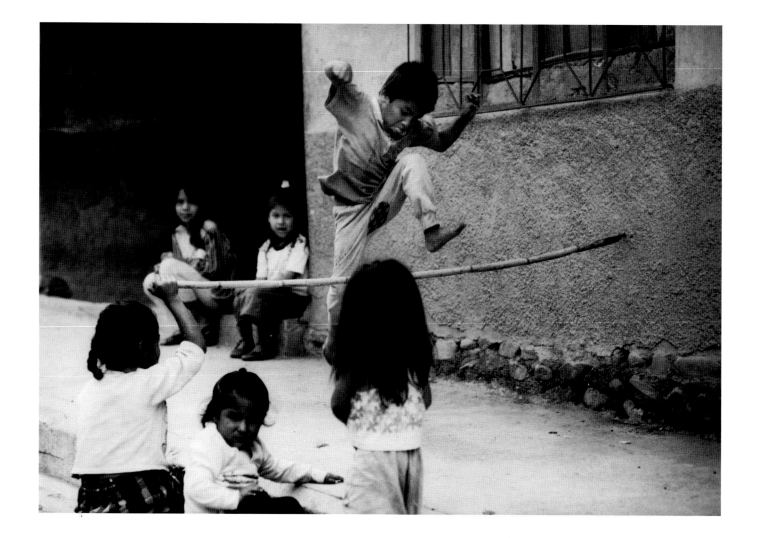

I left Vilcabamber refreshed and made my way north to Bucay. As with most journeys I had taken by bus through South America, bus stations were always utter mayhem. Vendors bundled onto the buses to sell their home-made snacks, which included corn on the cob, chips, chicken legs and ice creams. Their repetitive songs, loudly advertising their snacks were almost melodic.

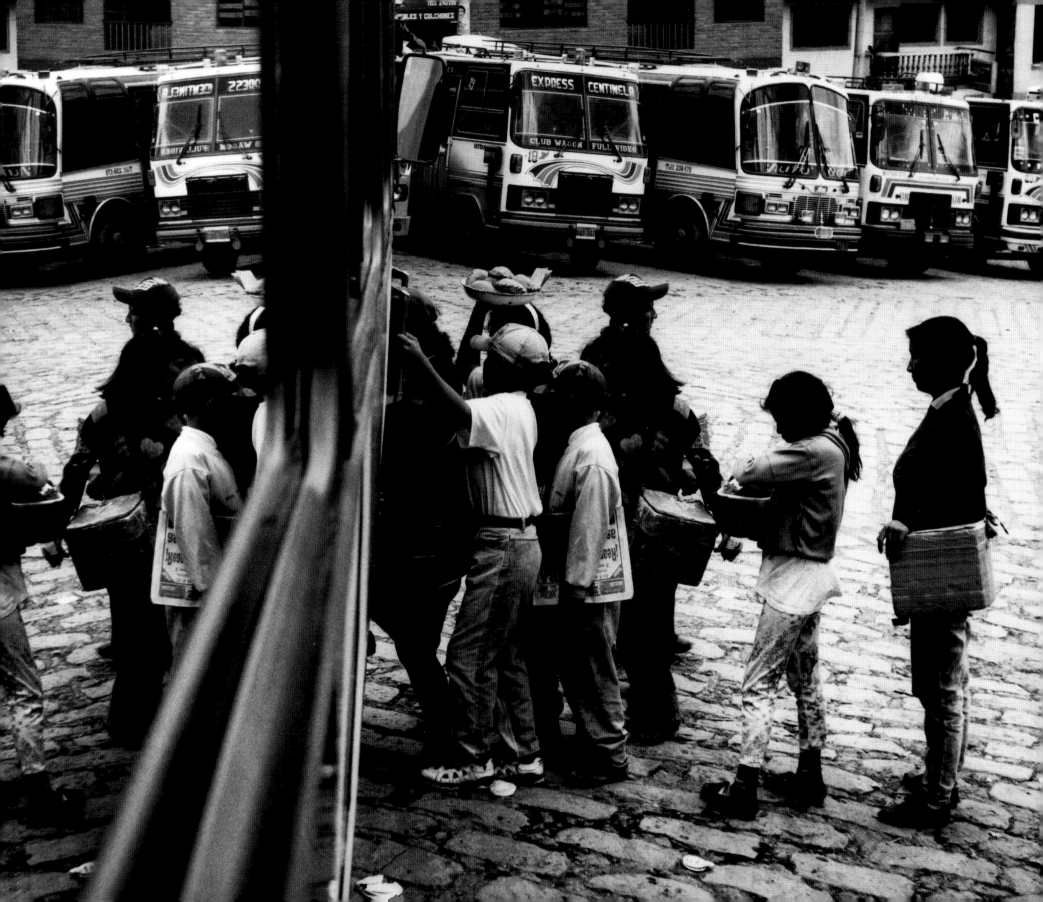

Bucay was a dead end town whose only purpose was as a main line train station to Riobamber. We had arrived in the evening, and having booked into a hostel, headed in search of a restaurant. This proved difficult as there weren't many facilities for travellers or even the locals. On looking out over the town early next morning, it became clear that most homes have a television set, even though they have little else in terms of material possessions like furniture and knick-knacks.

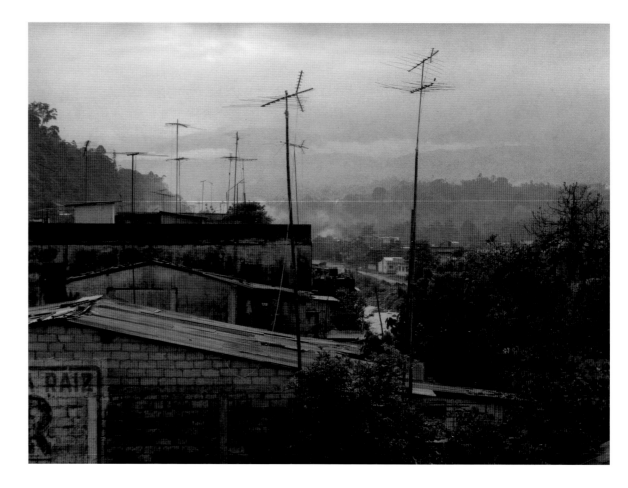

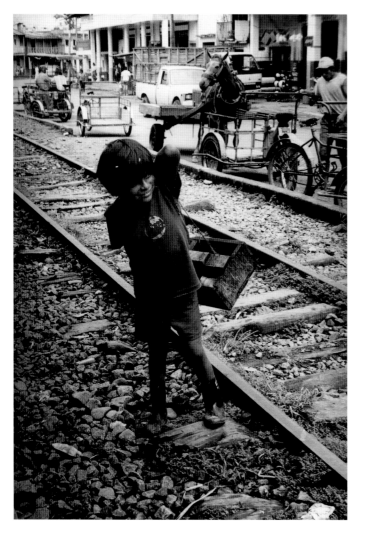

We headed to the station around nine, knowing that the train could arrive any time between then and midday - typically it arrived at midday. This rustic town was deserted except for a few shoeshine boys, but it broke into a frenzy of activity when the huge locomotive thundered into town. Suddenly it became a bustling market of people buying and selling fish and other produce from the train which had come from the coast.

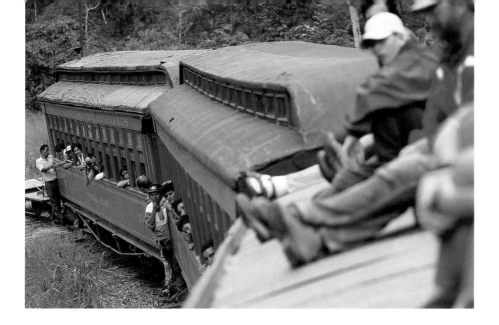

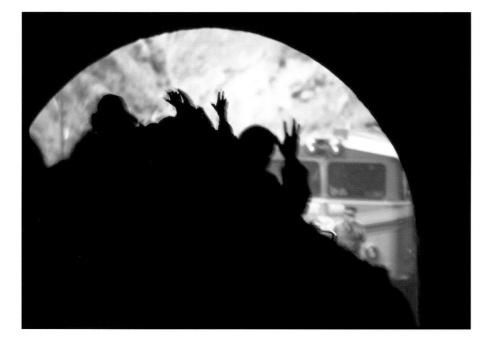

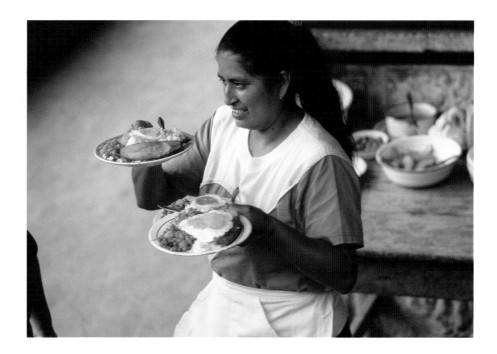

Heaving ourselves and our rucksacks onto the roof, we straddled the centre ridge, ready to face the wind and the much talked about views. It felt like we were on a shuttle going up 'Space Mountain'. This sensation may have been enhanced by the effects of a 'joint' being passed down the line, but I certainly wasn't imagining the changing beauty encapsulating me. From a humid sunny morning our journey took us though extreme weather conditions, altitudes and views. With the wind in my face and the variety of sights and smells passing me I became entranced with everything around me. The train was flagged down in the middle of nowhere. Snack men climbed onto the roof to sell biscuits and crisps. Ticket inspectors looked unsteady as they tried to keep their balance down the backbone of the train, ducking to avoid low tunnels. At one of the few stations we pulled into, women cooked up full blown meals on the platform. These one dollar lunches were passed up to the hungry passengers on the roof, who ate and then returned the plates before the train pulled away. The ticket price paid by foreigners enables the service to keep running. Without it, the local lifeline for many would become extinct. Our 'fourteen dollars' fare compared to the locals 'one' was definitely worth it.

I had to rush up north to meet a friend arriving in Quito from England. Quito is a mixture of colonialism and commerce. The city had been awarded the cultural award from UNESCO in 1978 and has had strict planning restrictions on any subsequent development. Consequently the old town is architecturally impressive. However it is not seen as a particularly safe place, especially at night. Most foreigners stayed in the new town which is a bustling hive of activity. There are numerous cafes, bars and restaurants, rich in flavours from all over the world. At night it turns into a pumping cosmopolitan atmosphere with enthusiastic club-goers. Rather than waste the limited time we had together exploring the city, we headed east to the beach, and the small picturesque island of Muisne.

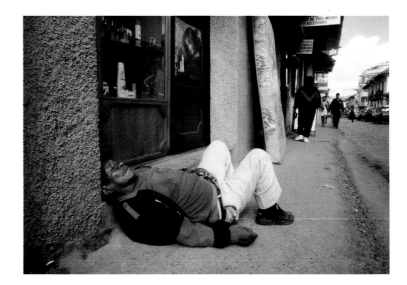

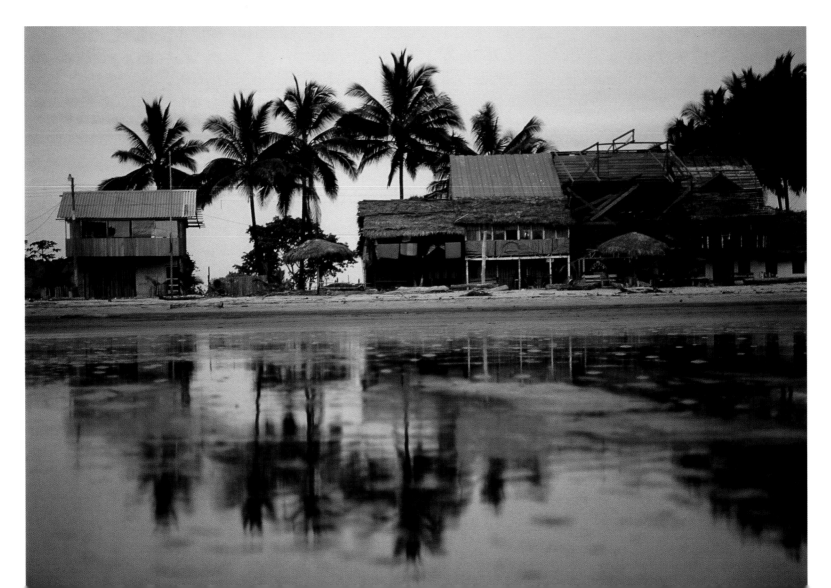

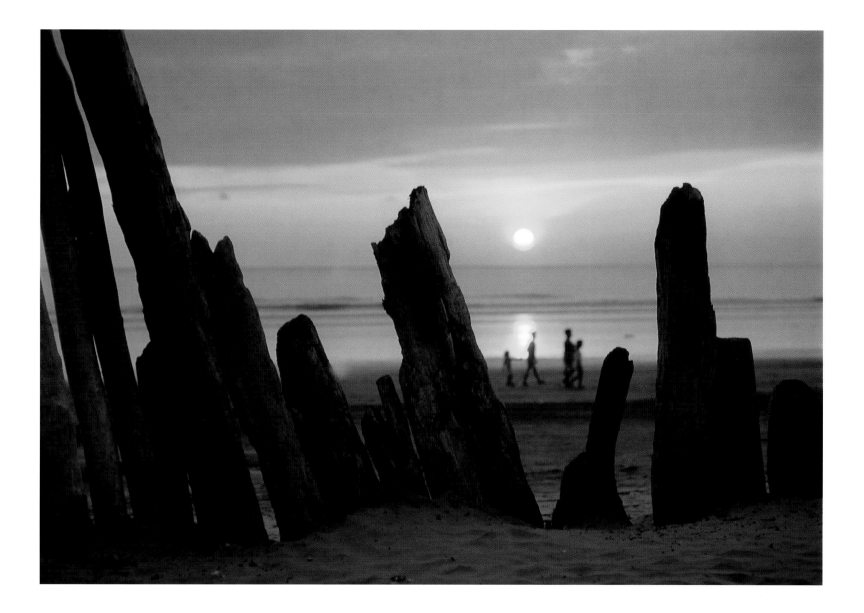

Muisne is a remote and seemingly tranquil, under-developed stretch of sand, on the north coast of Ecuador. It was difficult to believe that the morning we arrived, two hundred yards from our hostel, two girls had been robbed on the beach by a man with a machete. It's sometimes difficult to decide whether it's safer to carry your valuables with you or leave them where you're staying. I felt the hostel owner was trustworthy and after hearing this story, had no hesitation in leaving everything there. We spent three days lazing in a hammock in the shadow of a palm, eating the most delicious seafood and watching the sun go down. It was perfect.

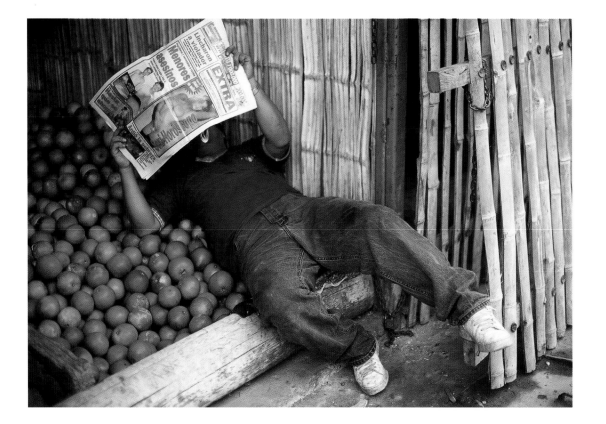

Feeling it necessary to move on and explore, we travelled back via Quito to Colombia, stopping briefly at Ipiales to change money. Word of mouth had sent us in the direction of San Agustin in the mountains another fourteen hours away. I'd heard about the dangers of travelling in Colombia with its history of civil wars and guerrillas, together with its reputation of being the world's leading cocaine supplier. The variety of ethnic groups form a culturally diverse society and its natural contrast of topography makes Colombia an interesting country to visit. There is a distinct presence of the military, but I felt no more threatened here than anywhere else. Surprisingly the customs formalities on the border were relaxed in both directions.

I sometimes wonder who's watching who? During our journey to San Agustin we had to deal with a child staring at us, a turkey gobbling by my feet, and a series of impromptu army checks which involved a quick search. Even though we had nothing to worry about, fear still grips you when you're an inch away from the end of a rifle. We had been travelling for about forty eight hours continuously, with only an overnight break in Popayan. Although exhausting, our journey included some of the most mind-blowing and magnificent scenery through the Parque Nacional Purace. The variety of landscapes - from volcanoes, mountain lakes, waterfalls, canyons, twisting valleys and hot springs were certainly amongst the best scenery I had encountered thus far.

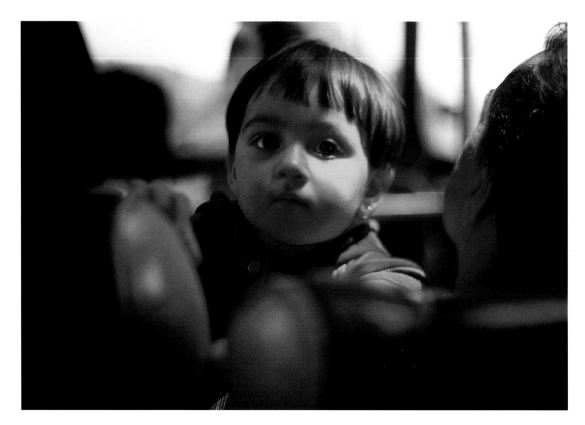

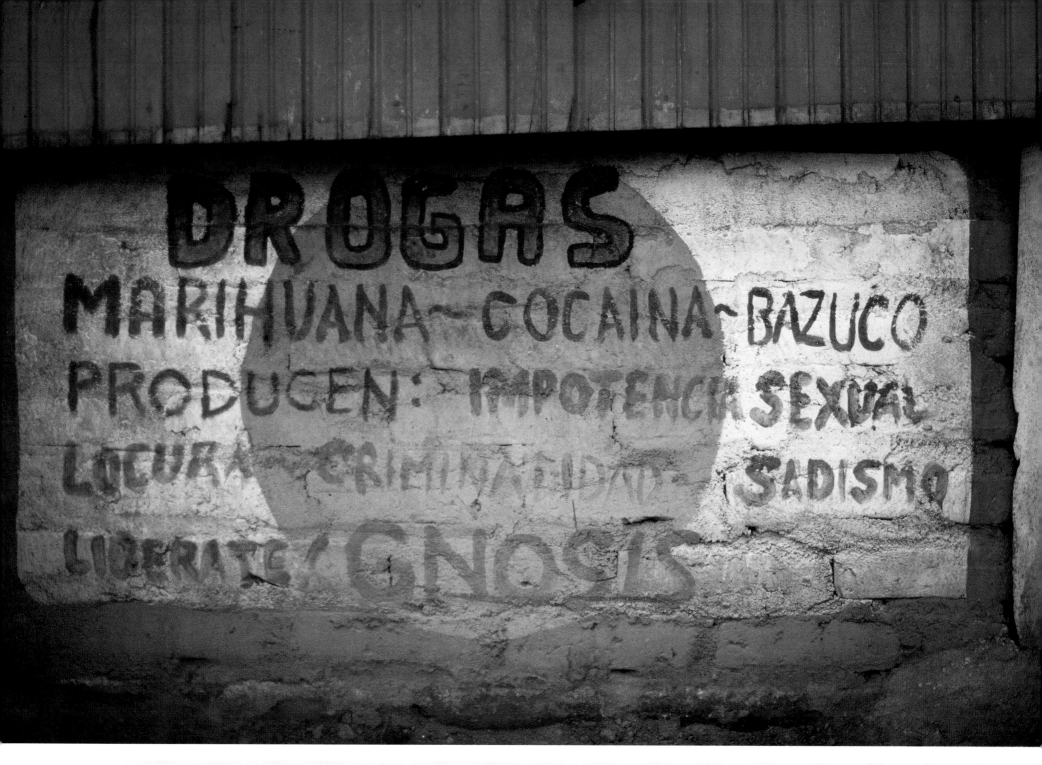

"Drugs - Marijuana - Cocaine - Bazuco produce : sexual impotency, madness, criminal activities and sadism - free yourself." It's a fairly clear message being spoken but it is largely unheard. Colombia's economy is run on the supply and export of cocaine to countries where it's difficult to keep up with the pace of life. We were in desperate need of sleep by the time we arrived in San Agustin but before we had even had time to find a bed for the night we were offered something to 'smoke' and something to 'sniff' by an over friendly tourist information officer. A spiritual aura filled the fairy-tale-like countryside which was strewn with ancient archaeological sights. Waterfalls and canyons could have been missed by many people, isolated in their rooms and also in their heads. Every drug imaginable was available and for less than a beer, so many took advantage and went over the top.

A different side of local life was seen through open windows at night. In each a memorable scene. From families crowded around a TV with little else to focus their attention on, to convenience stores in front rooms packed with fizzy drinks, snacks and coffee. This antique town was interesting to observe - in whatever state of mind.

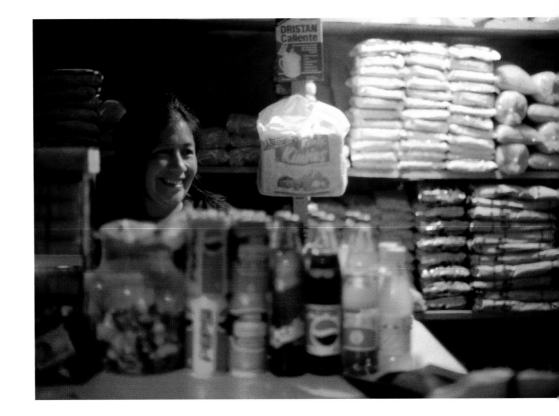

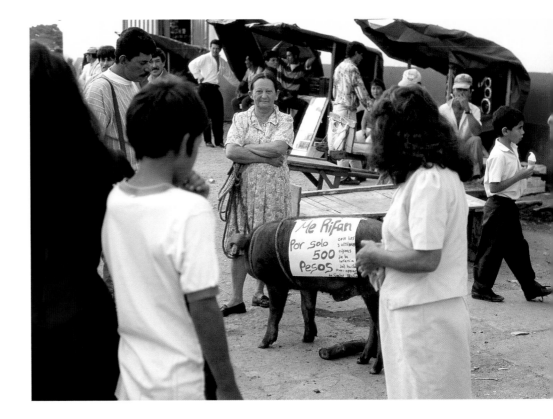

The 'scene' got too much, and we decided to head back south. Leaving early first thing we collided with the market. It seemed a shame to have travelled so far and to leave without any souvenirs. We grabbed some fruit for our journey and pondered on whether we could get the pig on the bus. Travelling without a guide book meant we could only go by recommendations. Although San Agustin had a great deal of charm, we wanted to find somewhere not so touristy.

Another mammoth bus jour-
ney! We arrived early in
Pasto and from there caught an-
other bus towards Laguna de la
Cocha. The hour long bus journey
dropped us at the end of a track
which led to the lakeside settle-
ment. Connecting once again
with nature, I saw the beauty in
what was around me. Simple
scenes caught my attention.

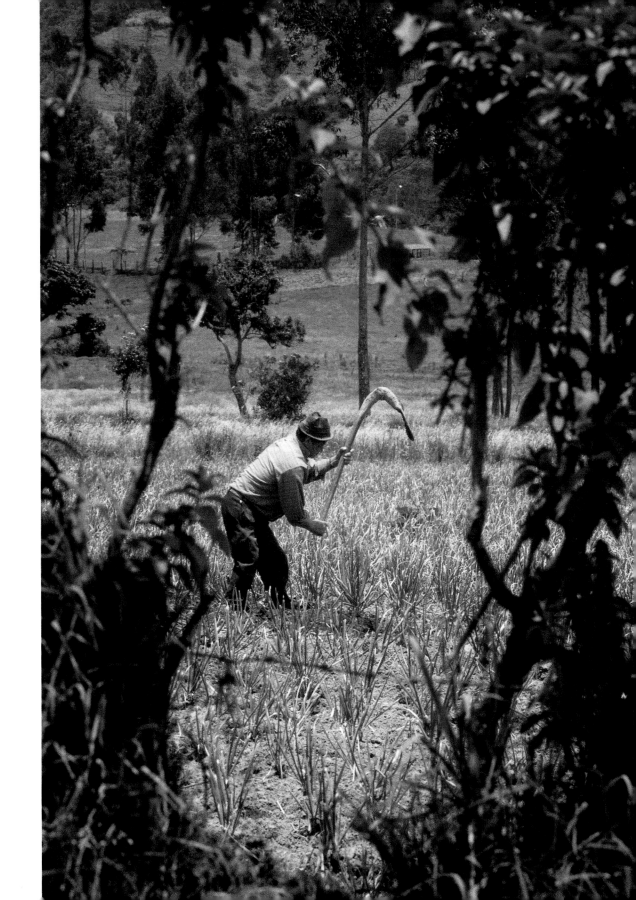

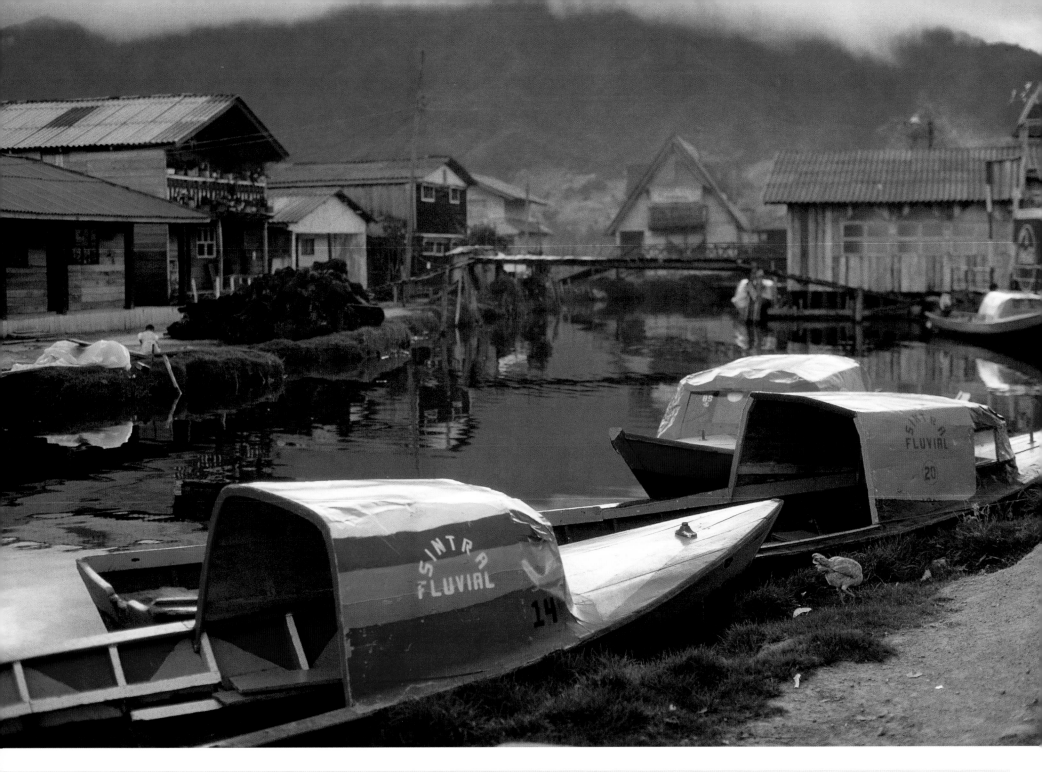

The village resembled a scene from Switzerland with its multicoloured wooden slat houses. It was an idyllic spot and thankfully we were the only foreigners. Needing to change money we asked around and, in a small store selling little else other than cigarettes, our fifty dollar note was studied with interest. After it was passed around half a dozen on-lookers, it was decided it was fake! The truth was they hadn't seen one before. From a choice of twenty different places to eat we were taken to an interesting establishment by the town drunk. It was the cheapest and visually most interesting place in town, selling everything from fresh fish to toiletries. A small kitchen in the store served a few tables out the front.

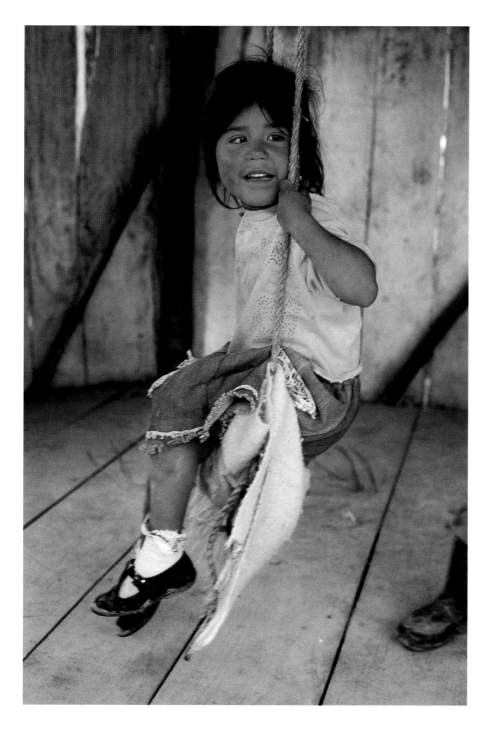

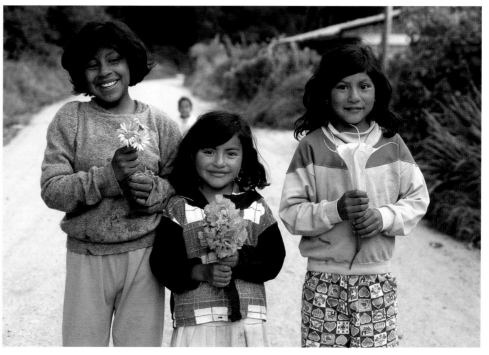

We decided to go back to Ecuador. Before crossing back over the border, children approached us with freshly picked flowers and greetings of *adios*. We thought it strange they could tell we were leaving, but we later found out that it was a way of saying 'welcome, how long are you planning to stay.'

Otavalo was a small town about three hours north of Quito and was the home of the most famous market in Ecuador. The market dates back to Inca times, where goods from the neighbouring lowlands and highlands were traded. The town has not only retained its charm and colour, but is enhanced by the constant flow of tourists who are now drawn to the extraordinary range of crafts on offer in the Saturday market. It is amazing that such a small town is responsible for such a wealth of exports, and increasingly the markets are a stopover for buyers from all over the world. Nevertheless the town still keeps its own tradition, even though it is heavily influenced by tourism

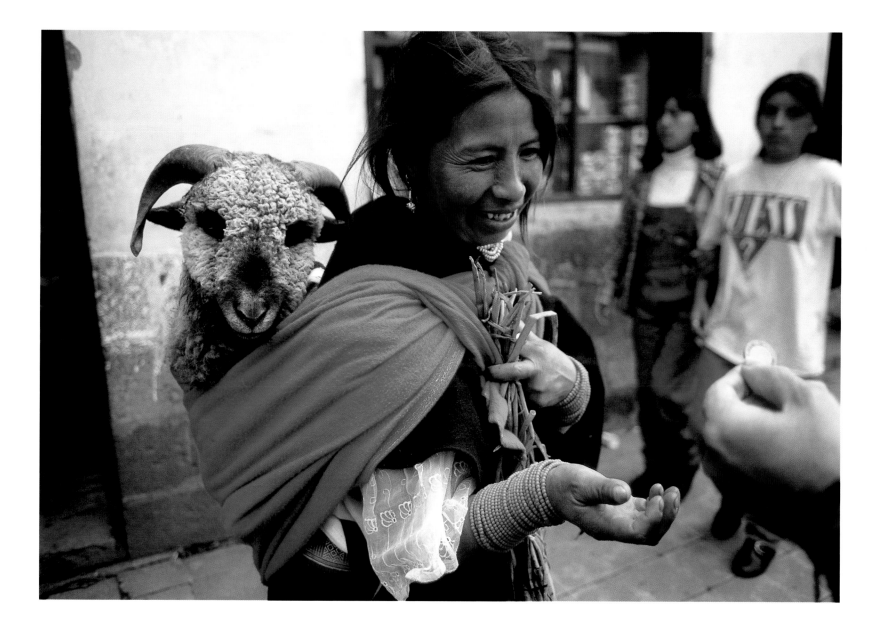

Alongside the main market area of colourful souvenirs, trinkets and a massive choice of jumpers, hammocks and weavings, is the local market. Guinea pigs, chickens, rabbits, cats and dogs were bartered for and most people who visit the markets leave with their purchases loaded on their backs.

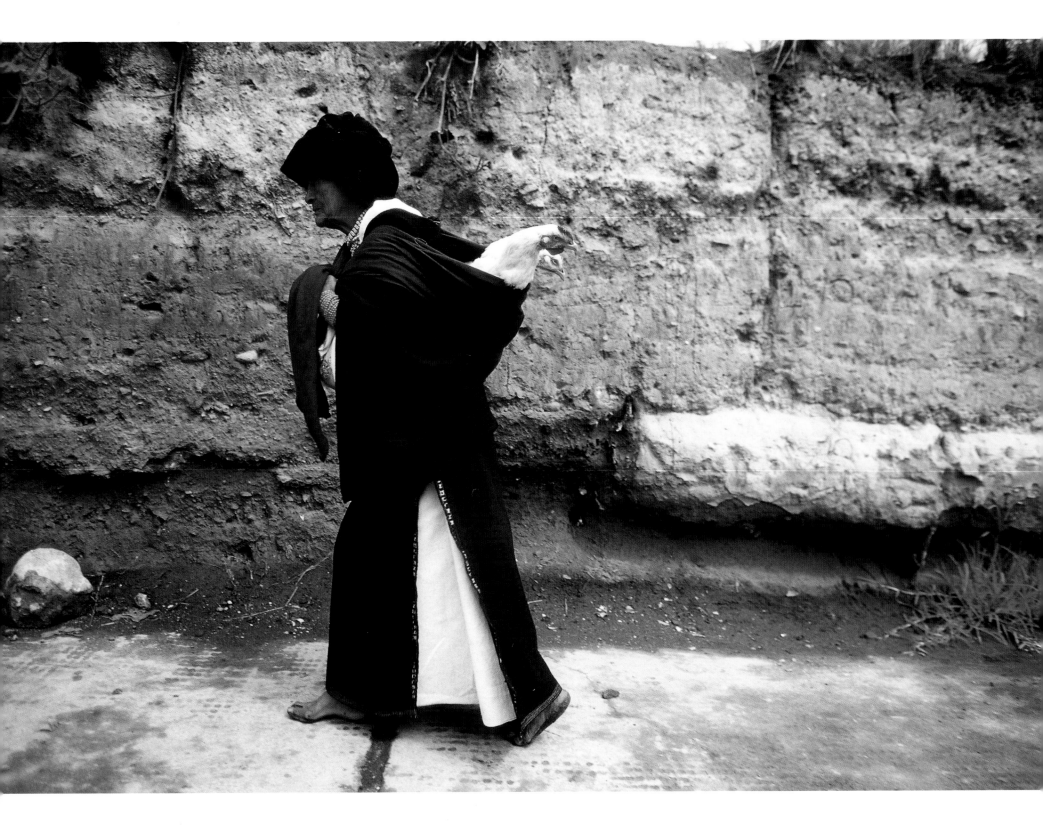

We hired bicycles for the day and headed out of town. Whilst knowing it was Easter week, we had no idea what the significance of the day was when we gatecrashed what seemed like a family reunion in a graveyard that we were passing. It later became clear that it was 'The day of the dead'. Friends and relations met to clean and redesign their loved ones' graves, spending the afternoon with them and enjoying a picnic.

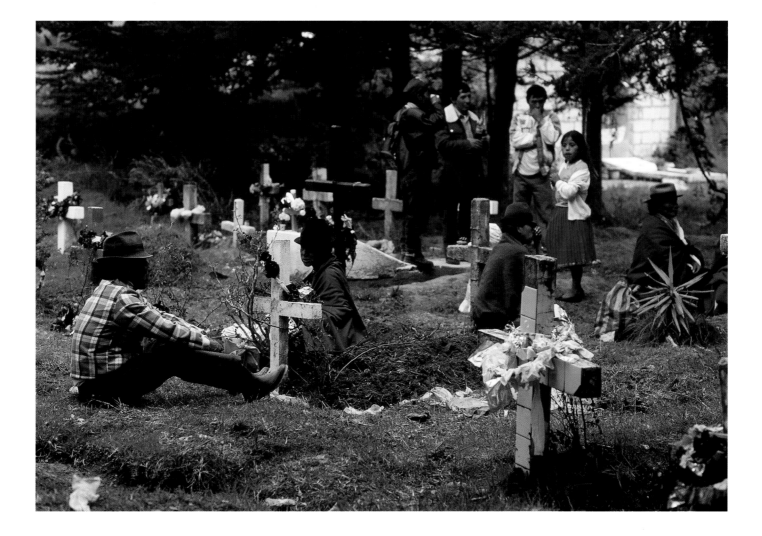

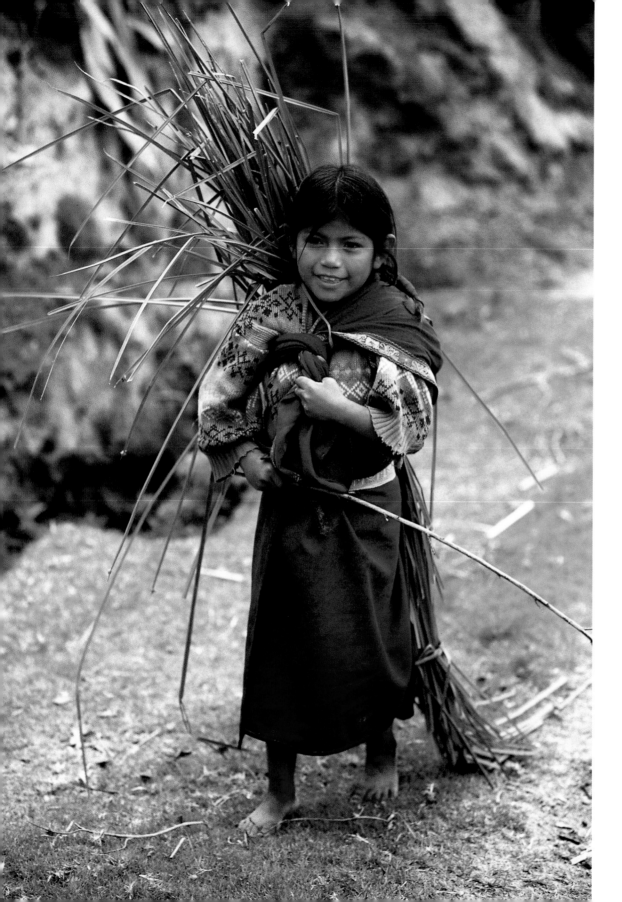

We carried on our ride which took us all day around the Lago San Pedro, observing the traditional lives along the way.

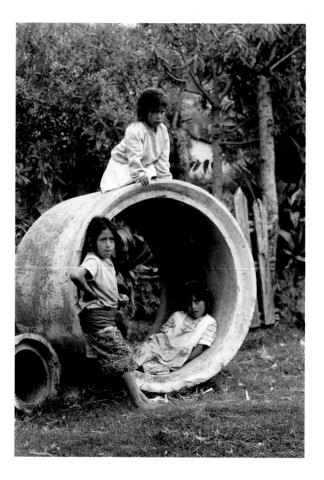

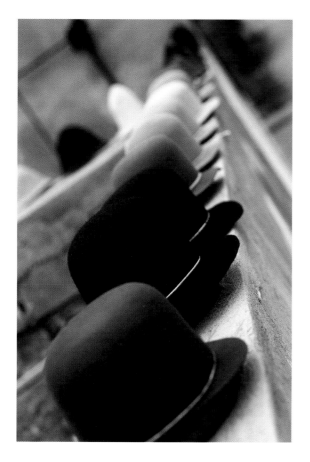

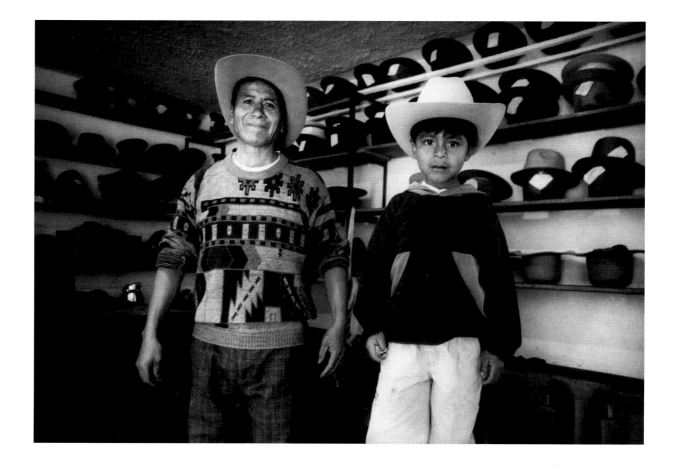

We came across a building decorated in hats. Every cove, window ledge and wall was lined with hand crafted hats of all shapes and shades. It was impossible to leave empty headed! As in all the countries I had visited there's a hat to fit every province and region, which is used as a form of identity - like having a tribal tattoo.

A little further along the track, another hat maker invited us into his workshop. Prices ranged from two dollars to eighty dollars (for a fully lined Sombrero which took three days to make). Hats are a very distinctive part of the culture, and although most wouldn't believe it, Panama hats are Ecuador's most famous export.

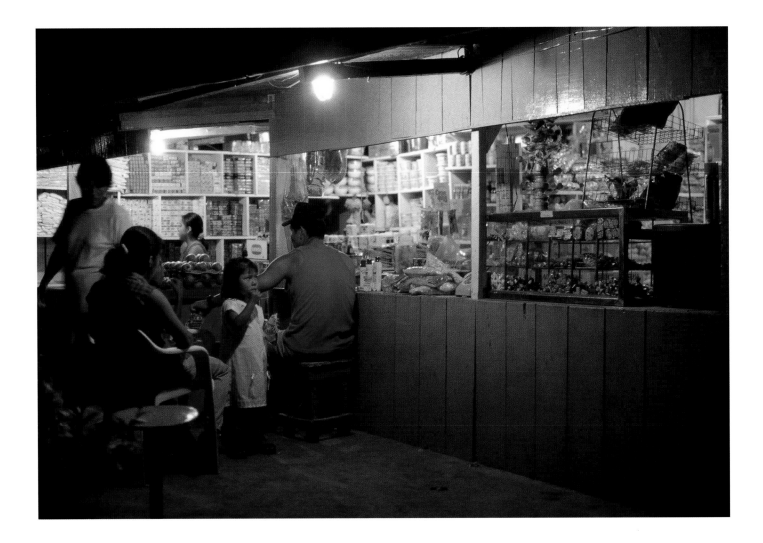

An emotional farewell to my friend left me alone again. When travelling as a pair or group you look out for each other, but when alone it's totally up to the individual to look out for themselves. Getting my head together I decided to make for the jungle. One of the missions I'd wished to experience whilst in South America was to visit the rain forests and jungle. I travelled up to Coca, a rustic town known for its oil excavation which is also used as a base for travellers wanting to take treks into the nearby jungle. The town was dead when I arrived late at night. A few local bars and stores were open, and searching for somewhere to stay through the eerie streets illuminated by a single street lamp was difficult because most places were full. I ended up in a dodgy hostel which was part brothel/ part home for local oil workers. It was cheap, bearable and strangely interesting. Searching for company, I had a drink in a bar to quench my thirst, and met Jon, a Dane, who was looking for someone to go into the jungle with.

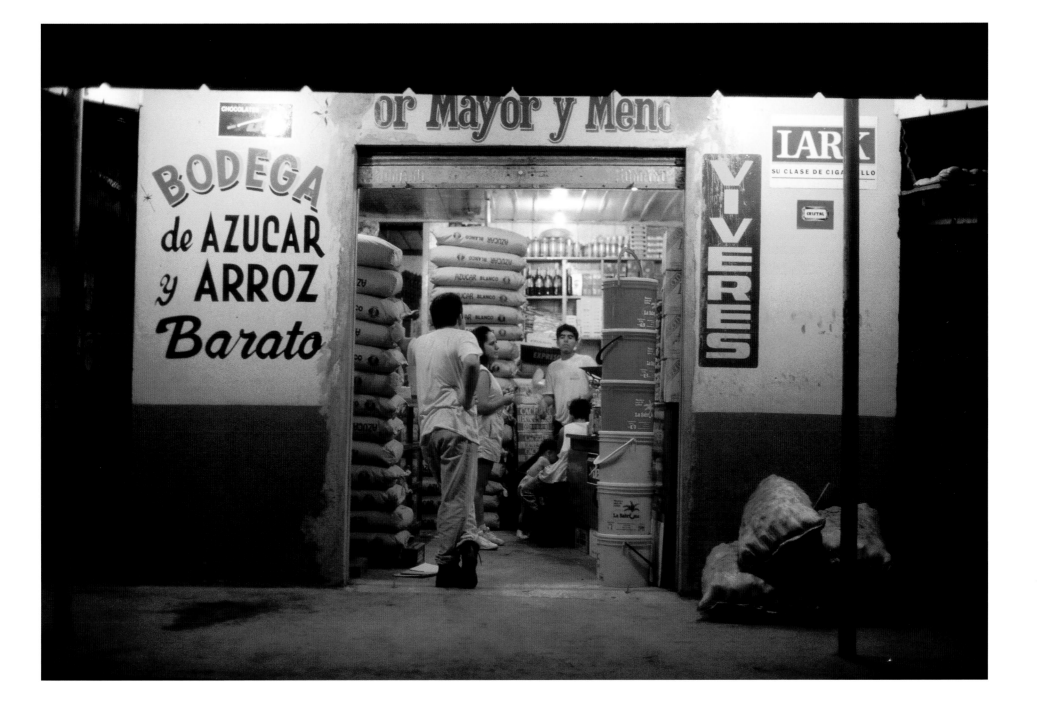

After spending a day trying to find a guide to take us into the jungle, we decided it was cheaper and more practical to take a tour. Hoping for a guide who had loved, lived and breathed the jungle all his life, we were slightly disappointed to hear that ours had only been a guide for three years. Thinking positively, we crouched into our dugout canoe and floated downstream. I became concerned for our safety when water started pouring through cracks in the wood by my feet! The discomfort and danger was soon forgotten as we entered the lush vegetation and dense primary jungle.

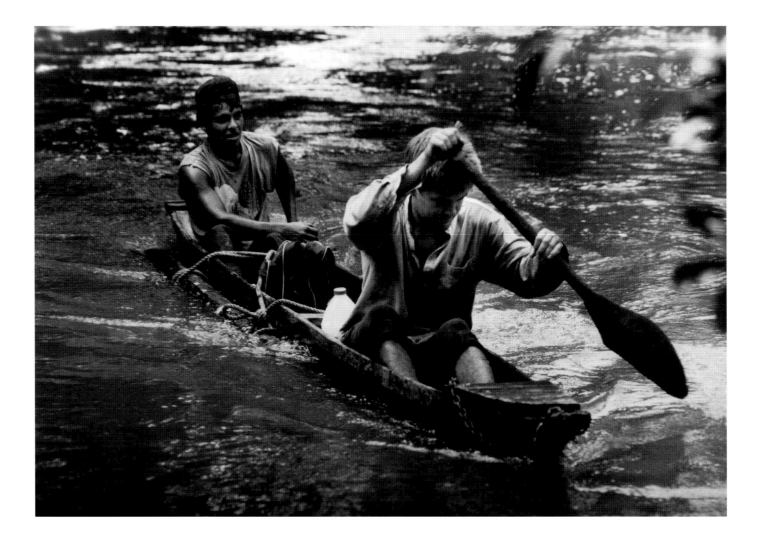

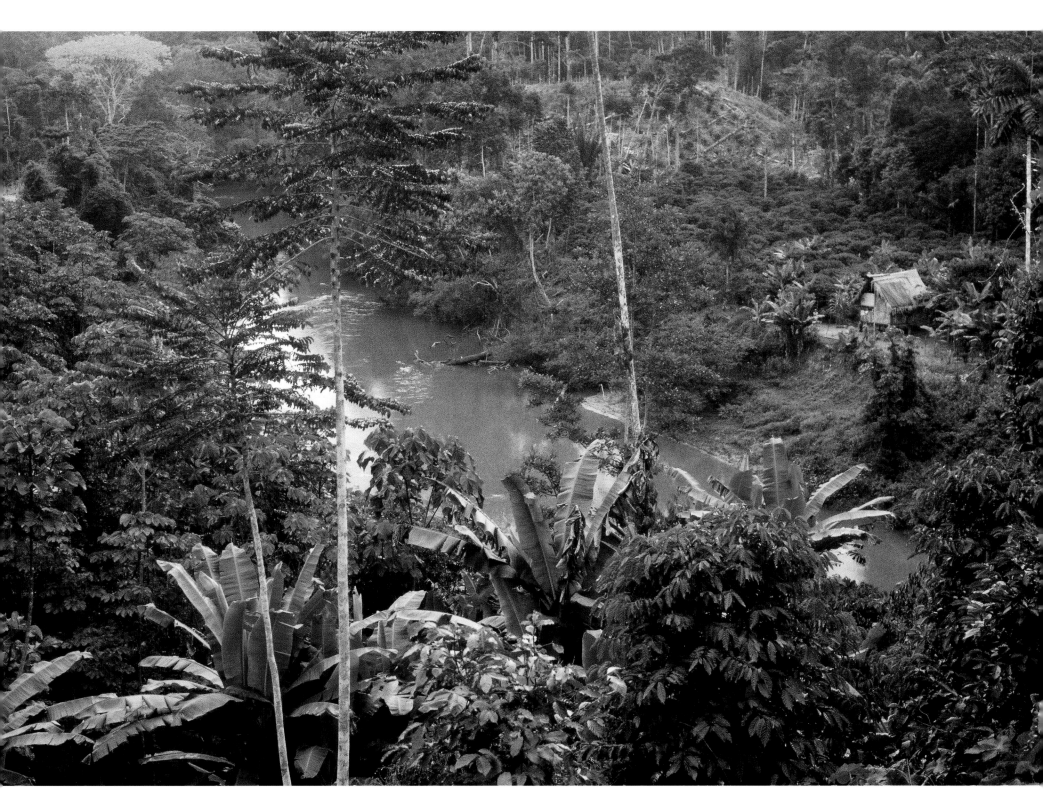

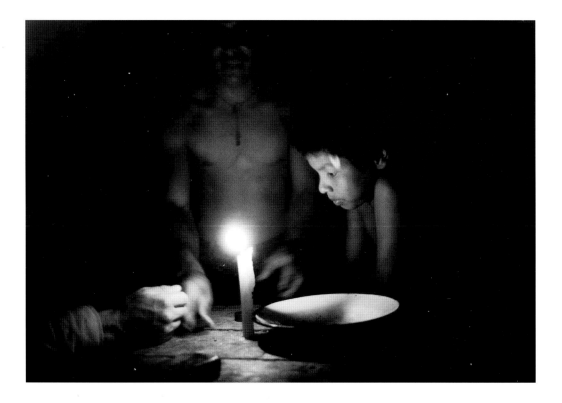

Our first camp was a derelict shack. Due to the humidity, I overcame my fear of being eaten by a Piranha and cooled off in the Tiputini River. Dinner was a tempting cuisine of stodgy pasta and rice with tomato ketchup, after which our guide entertained us with his favourite tricks. We were left hoping he hadn't exhausted all his resources on the first night! Wanting to be 'toxin free', I purposely hadn't brought any alcohol, but I was seriously regretting it. Only six more nights to go!

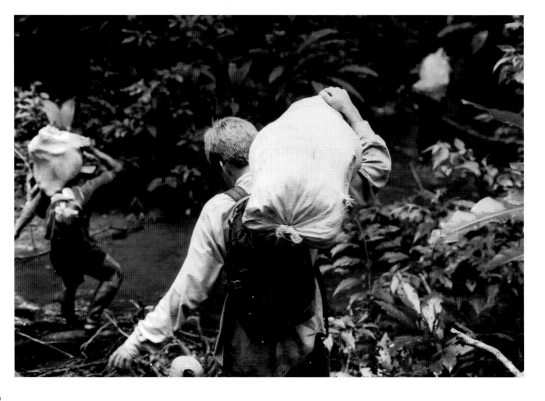

With tents, food and cooking utensils loaded onto our shoulders we moved camp, this time into the heart of the jungle. Having hoped for an eco-friendly tour and surviving off what the jungle could provide us, we were instead faced with tinned pilchards in tomato sauce with chips for breakfast. The tin was then disposed of down a snake hole.

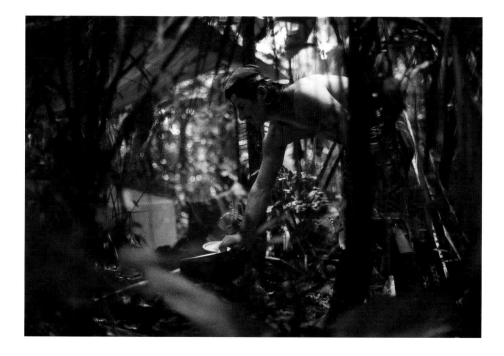

It was shocking watching our guide tear through the jungle with his machete, destroying plant life without a thought. Ten feet square sections of homes, foliage and animal life were flattened to accommodate our camp. I was ashamed to be part of the destruction, but it reminded me of the damage of tourism to these sacred places. I had wanted to experience the jungle, but paid for it more than in monetary terms.

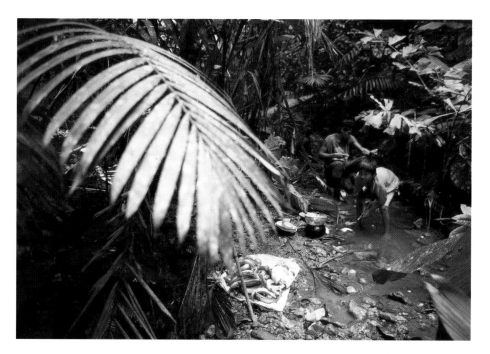

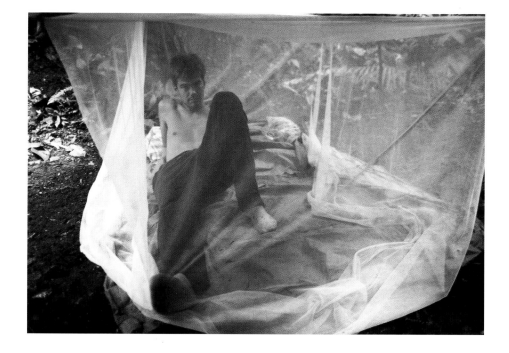

The jungle is not a fun experience. It's a harsh reality of survival and an endurance test of patience and practical resourcefulness. I sat for hours one afternoon, hiding in the mosquito net to protect myself from the flies. Everywhere I went they followed me. My sweet smelling sweaty skin attracted them to me like bees to honey. Even the net wasn't safe. However secure you might feel, they always seem to find a small hole and invite all their mates to the feast. Five hours later, with the exception of a few excursions to the loo, I was still sat inside, it was like a torture chamber. If I didn't go mad constantly flapping my hands, I might do so from the constant hum and buzz of the insects circling me like *Schumacher through a chicane!* But sleeping out in the elements does have its advantages. At night, when the fire is out, the only light is from the moon above, fighting its way through the canopy creating crazy shadows. Insects with UV green eyes circled us like lasers and blended with the myriad sounds.

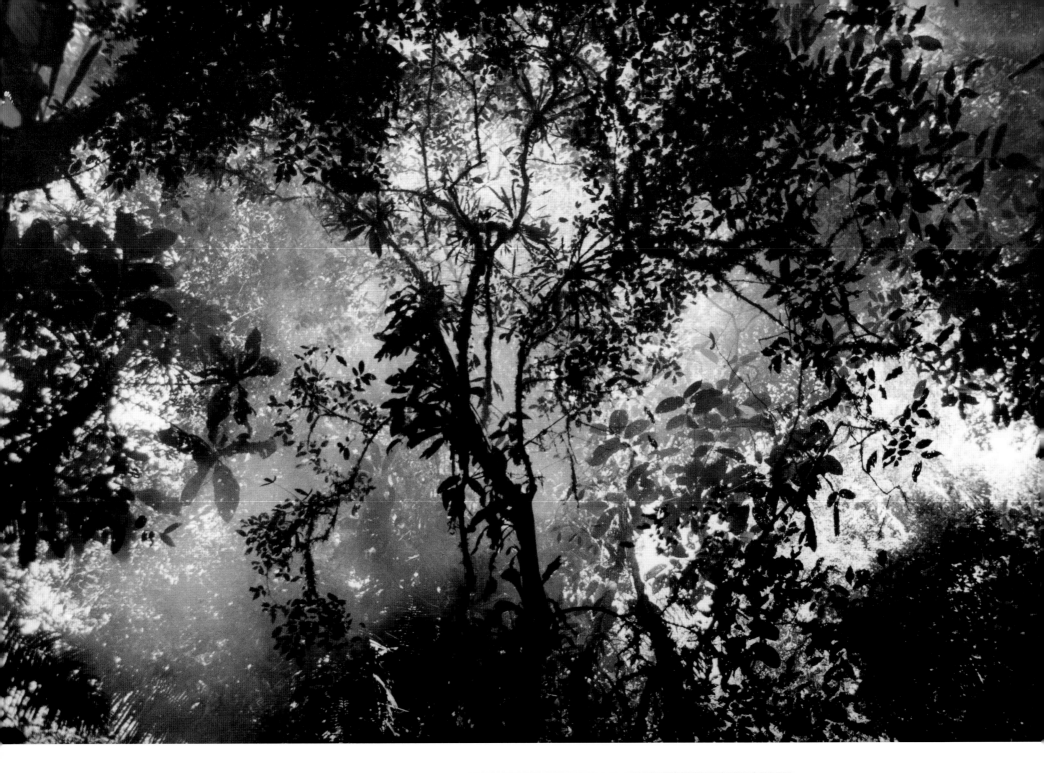

Despite the guide's lack of English, my companion was able to translate the 'spiel' about the qualities of various plants and seeds. It was fascinating to learn about their healing and health properties, and how they were still used by the indigenous people from the area. This somehow slightly compensated for the fact that after a while I started to realise that we were being walked around the same square mile for the entire expedition!

Returning from our expedition we enjoyed a beer together and reflected on the trip. We hadn't been Piranha fishing as specified, we hadn't met any indigenous people, our guide was unable to cook and his lack of respect for the jungle was disappointing. We had chosen to live in the jungle for seven days and had paid two hundred dollars for the privilege of this experience, but if there was ever to be a next time I would spend more time researching a tour company. Some are only interested in money. However - the positive side was that a lot was learned from the trip and a lifelong friendship made.

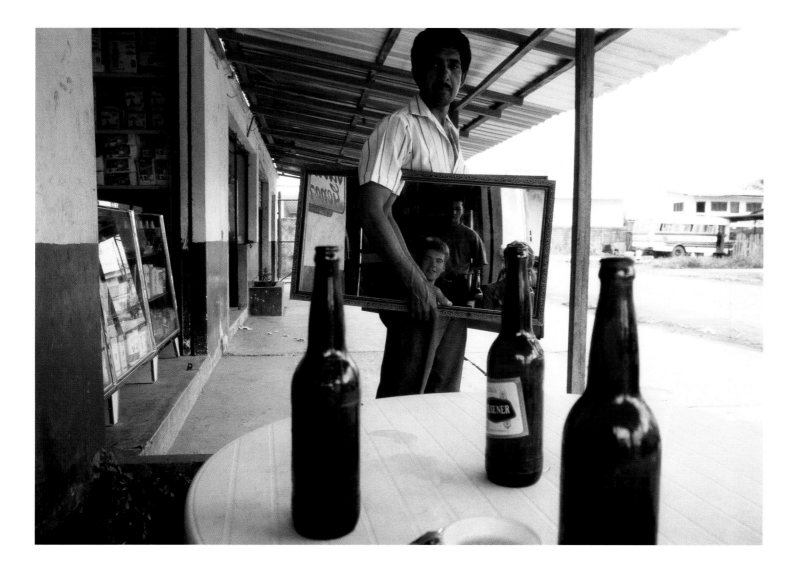

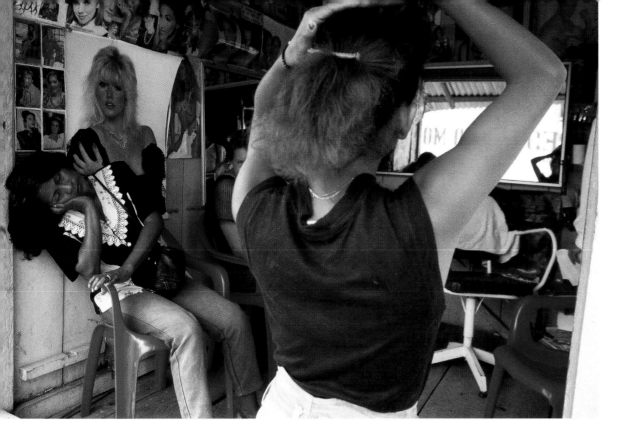

Even though Coca is a rustic, undeveloped town that moves at a snails' pace, there was enough to keep me amused but I had to start to make tracks back to Quito. It's strange that no matter how much time you spend away, the last ten per cent of the holiday is spent thinking of going home.

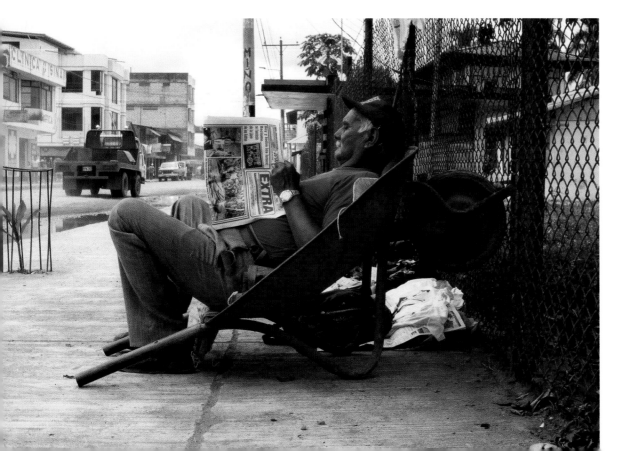

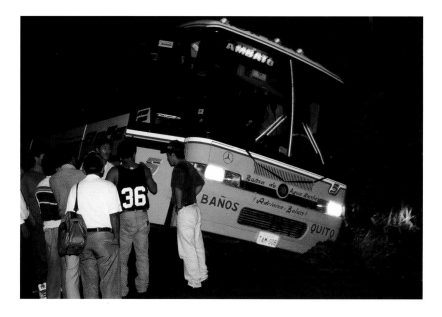

Taking the night bus to Banos I was woken from a deep sleep and found myself at a forty five degree angle! The bus had somehow left the road and landed in a ditch. This, together with a landslide further along, delayed the trip by five hours. The only good side to this delay was that I was able to see the scenery at daybreak, through the morning mist.

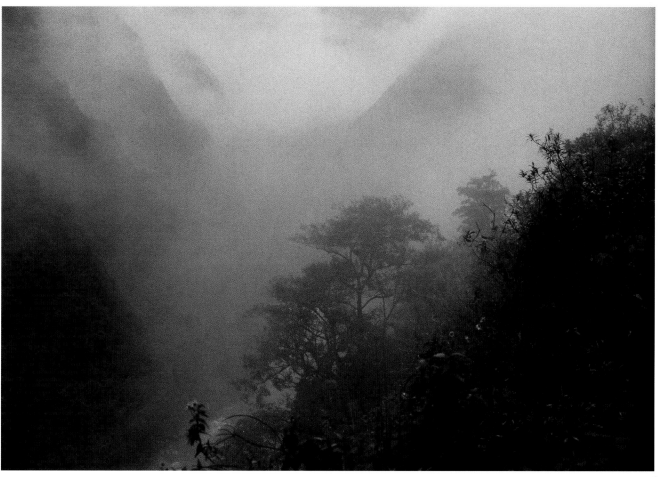

The town of Banos lived up to its name. It means bathroom in Spanish and the weather was appalling! I spent the day in bed recovering from the seven sleepless nights in the jungle and treated myself to a steam bath. People visit here for the scenery, to take jungle trips into the nearby Orient, or just to relax in the famous hot spring baths.

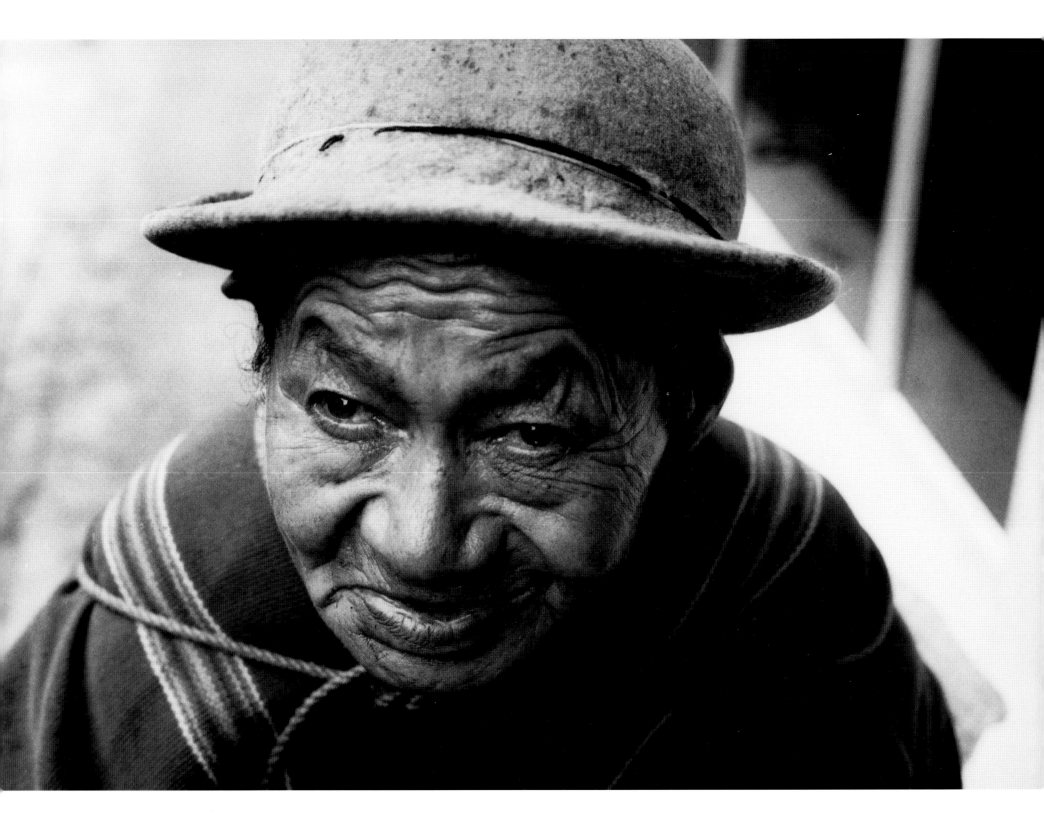

I often wonder why I'm able to recognise fellow travellers' faces even after very brief encounters. In the first three weeks of my travels I was isolated from contact with other travellers, yet since arriving in Ecuador had bumped into a number of people, again and again who I had previously met in other countries. Local faces seem less recognisable, though some faces you never forget whether they are associated with an experience or special moment. I left Banos to spend my last day in Saquisili two hours south of Quito. My final stop before catching my plane home. It is said to have the most interesting and important Thursday market in Ecuador, and is mainly for the inhabitants of remote villages around the area. There is a small section devoted to tourists and for me this was a good opportunity to pick up those last few souvenirs.

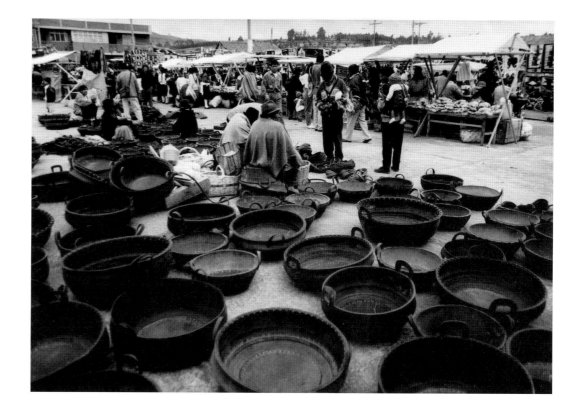

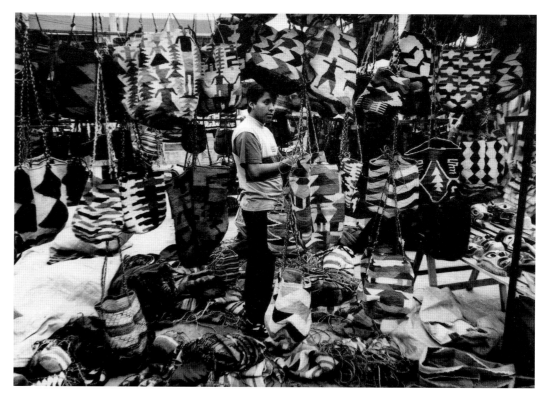

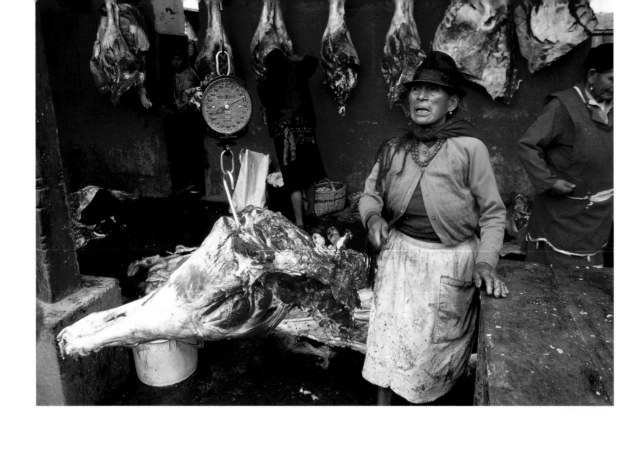

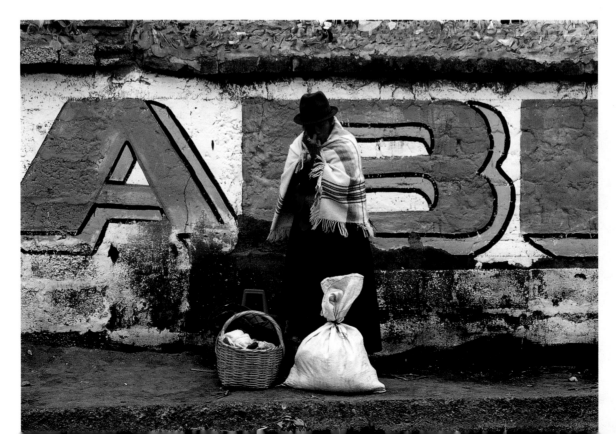

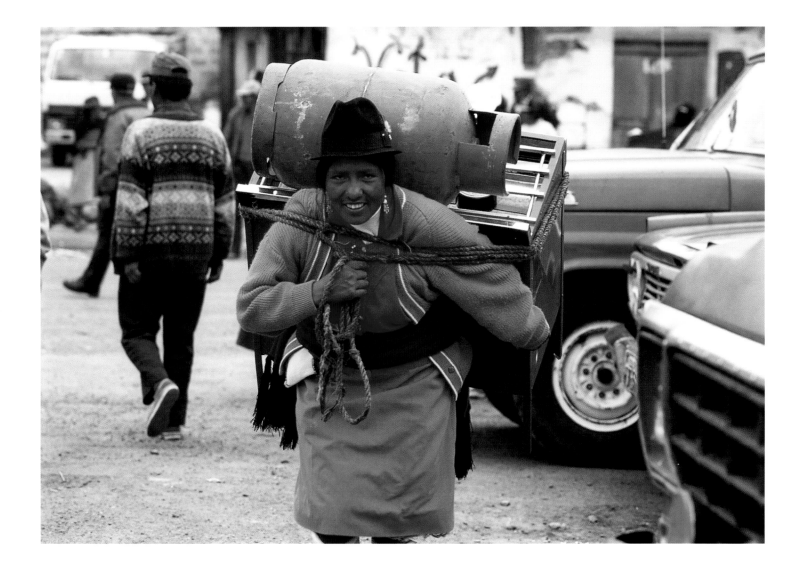

After travelling for three months in and out of other peoples lives it was time to return to my own. I left with a head full of memories and a rucksack full of souvenirs. The last memorable image I had was of a woman going home from market, carrying everything bar the kitchen sink!

travel tips

Learn the language before you go. Languages are rarely spoken except for Spanish (the national language) even in the major cities.

Take a credit card for ease and peace of mind in case of emergencies.

Take a student or teacher's card. It can save you money when visiting places of interest, historic sites and museums.

Take a padlock and key for double protection. In hostels you can be sure that their key won't fit your lock.

Take postcards of your home town and a family photo, it fascinates the locals.

Check the weather patterns and climates in the regions you are to visit to save time getting stuck in certain areas from frequent landslides.

Pack clothes to suit the conditions.

Photocopy Passports and other important documents.

Money belts are prime targets for thieves. Place money about your body - even sew hidden pockets into underwear.

Take a good book for company. Books other than in Spanish are hard to find even in the major cities, though it is possible to swap with other travellers that you meet along the way.

Remember to have the necessary injections and even dental and health checks before leaving.

Leave your trendy trainers at home and invest in a decent pair of hiking boots.

Sandals or flip flops are a comfort when showering in unhygienic bathrooms.

Name brand sunscreen products are hard to find in South America.

It's a good idea to take along a musical instrument, a juggling toy or know some songs, when you need to make your own entertainment.

Watch out for cheap tours, shop around and talk to other travellers. It sometimes pays off to pay more. Double check exactly what you get for your money. Some can be misleading and neglect to include first day meals or last day transport.

Watch out for money changers, especially on the borders, who sometimes have their calculators rigged to read low.

A good way to pick up the language is to watch English films subtitled in Spanish. Many long distance luxury coaches show videos. Alternatively most large towns and cities have cinemas.

For smokers Rizlas are difficult to find and a popular substitute are the Falklands pages from the South American Handbook.

Best of all take along an open mind and plenty of room in your rucksack for knick-knacks and souvenirs.

yummy foods

Most restaurants and cafes throughout South America offer a 'menu del dia' (set meal of the day), which is excellent value and usually has three courses - soup, main, salad and a drink.

Peru
Huancayo region - **Papas a la Huancayana**, Cold potatos covered in a mild hot cheese sauce served with an olive and slice of egg. Cheap and delicious!

Trujillo - Cake lovers would be in heaven here.

West coast - **Ceviche** - A delicious dish made from raw fish marinated in onions, chilles and lemon juice. served with sweet potato, corn on the cob and salad.

Lake Titicaca - **Trucha** - Fresh trout.

Colombia
Laguna de la Cocha - **Trucha Ahumada** - Smoked trout fresh from the lake. Served with blackberry juice (**mora**). Try it for breakfast!

Ecuador
West coast and major cities - **Ceviche** - As above but marinated in either lemon, orange or tomato juice and served with popcorn. An alternative to fish are shrimp (camarones)

Muisne - **Camarones Enconcado** -Prawns in coconut sauce served with fried plantain (bananas) and salad is worth trying.

South American snacks and drinks - Juice drinks - **Jugos de Mora (blackberry), naranja (orange), maracuya (passionfruit).**
Empanadas - Pasty type pies filled with meat (carne), vegetables (verduras) or cheese (queso).
Cuy - Roasted guinea pig, a speciality eaten mainly in the hills, in markets and at street stalls.
Choclo con queso - Corn on the cob with cheese, available on most street corners or in bus stations.
Palta - Avocado, cheap and delicious - excellent for packing a picnic for those long distance journeys.

Have you got a copy of our first book in the Trail of Visions series?

"A Trail of Visions is much more.......Vicki Couchmans photographs do tell with clarity what it's like to follow a trail across Asia: both the places you see and the people you meet."
The Independent on Sunday.

".....the illustrated record - through India, Sri Lanka, Thailand and Sumatra"
The Times.

"..the real value of her photos stems from the relaxed disposition of her subjects. It's as if she were invisible...her journals combine with her pictures to provide the most lucid insight into travelling this side of Heathrow."
Rasp Magazine.

"This is the first in what will hopefully become a series."
The Geographical Magazine.

"A Trail of Visions is a stunning photographic essay of travels through Asia."
Wanderlust Magazine

It was the second best selling illustrated travel book in the run up to Christmas 1996 in major bookshops.

It is available in all good book shops - ISBN 1-871349-33-8 priced £14.99
It is also available by sending a cheque or postal order made payable to Travellerseye Ltd to
30 St. Mary's Street
Bridgnorth
Shropshire.
WV16 4DW.
Please write on the back of the cheque the quantity and title that has been ordered.
Please allow 28 days for delivery.
Please include £3.00 for P&P. On collective orders of £25 or more (includes all Travellerseye merchandise) P&P will be free.

Travellerseye are excited to announce a new series of books -
Travellers Tales From Heaven & Hell

This is a collection of the best entries from the competition we ran earlier this year. Travellers of all ages sent in stories about their travel experiences from 'Heaven' or 'Hell'.

Everyone will be able to relate to some or most of the short anecdotes, and enjoy reading them.

It is an ideal bedside companion, or a book to dip in and out of, on occasions such as train journeys.
Life is full of ups and downs and these are often exaggerated when travelling.
Travellers Tales from Heaven & Hell extols these and is recommended to anyone who enjoys hearing about the real life extreme highs and lows in an amusing 'tongue in cheek' way.

It is available at all good bookshops ISBN 0 9530575 18 for £6.99
It is also available by sending a cheque or postal order made payable to
Travellerseye Ltd to
30 St. Mary's Street,
Bridgnorth,
Shropshire.
WV16 4DW.
Please write on the back of the cheque the quantity and title that has been ordered.
Please allow 28 days for delivery.
Please include £2.00 for P&P. On collective orders of £25 or more (includes all Travellerseye merchandise) P&P will be free.

We are pleased to be able to let you know that if you have had a particular experience that you want to tell us about then we will enter it into our future Heaven & Hell competitions. Prizes for the best entries to our first competition included flights to New York, Paris and Amsterdam, and we are going to be offering bigger and better prizes in 1998.

The chapters in the books are - jobs, transport, accommodation, days out, nights out, tourist attractions and food & drink. We are looking for edited copies of letters to friends or family or diaries that start 'You won't believe what has just happened to me...' and go on to recount a specific experience such as that heavenly meal, or cockroach infested bathroom shared with a corridor of people.

In 1998, we are splitting up the book into continents. The closing date for the 1998 publications will be 1st August. When submitting your tales we need to know your name, date of birth, address, continent and country of experience and whether the tale is from heaven or hell. There is still a 1000 word restriction on the amount of words each submission can be. As there will be six books being released all with the same number of tales in there is an increasing chance your tale could be a winning one. So get writing!

Details will also be available on our web-site http://www.travellerseye.com, and in national and local press.

Greetings cards

1 2 3 4

5 6 7 8

Travellerseye have just launched their first set of blank greetings cards. They will be available in good gift/bookshops or alternatively direct from us by sending a cheque or postal order made payable to
Travellerseye Ltd at
30 St. Mary's Street,
Bridgnorth,
Shropshire.
WV16 4DW.
Cards are £1 each or £6 for a set of eight inc vat.
State clearly which cards you require and please include £1 P&P. On collective orders of £25 or more (includes all Travellerseye merchandise) P&P will be free. Please allow 28 days for delivery.
Orders outside UK please contact us for details.

essential reading

Rough Guide to Peru

Lonely Planet South America

South American Handbook

The Fruit Palace
 - Charles Nicholl

Motorcycle Diaries
 - Che Guevara

Love in a Time of Cholera
One Hundred Years of Solitude
News of a Kidnapping
 - Gabriel Garcia Marquez

The Old Patagonian Express
 - Paul Theroux

On the Road
 - Jack Kerouac

The Celestine Prophecy
 - James Redfield

Zen and the Art of Motorcycle Maintenance
 - Robert Pirsig

Fear and Loathing in Las Vegas
 - Hunter S Thompson

A Trail of Visions Route 1.

Travellerseye on the Internet

If you're interested in travelling and have occasion to 'surf the net' get your browser down to

http://www.travellerseye.com

Includes:

Global Club Guide
Snailspace Magazine
The best Travel links on the net
Exclusive details of future Travellerseye publications.
First hand details of Heaven & Hell 98 - your chance to win flights around the world just by telling us your stories.
& so much more !!

We're looking for your input, to help the site grow into the most comprehensive resource for all those travel minded people who want to share their experiences or just find out where best to party in Tokyo.

Paddle out and ride our electrical waves back into shore.

e-mail travellerseye@compulink.co.uk